THE
PHOTOGRAPHER'S
SURVIVAL GUIDE

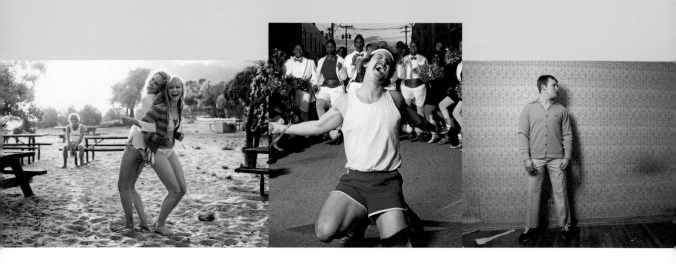

HOW TO BUILD AND GROW A SUCCESSFUL BUSINESS

THE PHOTOGRAPHER'S SURVIVAL GUIDE

SUZANNE SEASE AND AMANDA SOSA STONE

WATSON-GUPTILL PUBLICATIONS | NEW YORK

ISBN-13: 978-0-8174-7677-9

LIBRARY OF CONGRESS CONTROL NUMBER: 2008935794

Senior Acquisitions Editor: Julie Mazur
Art Director: Jess Morphew
Editor: Patricia Fogarty
Designer: Debbie Glasserman
Production Director: Alyn Evans

Opposite the title page: Photographs by Nick Onken (left) and Colby Lysne (middle and right).

Manufactured in China
First printing, 2009

1 2 3 4 5 6 7 8 9 / 15 14 13 12 11 10 09

We offer a very special dedication to
Elyse Weissberg (April 9, 1956–July 21, 2001).
Elyse was one of the greatest consultants of our
time. Her knowledge and words will always be
remembered.

We highly recommend Elyse's book, *Successful Self-Promotion for Photographers: Expose Yourself Properly* (New York: Watson-Guptill Publications, 2004). Before you read anything—even *The Photographer's Survival Guide*—you must read Elyse's book.

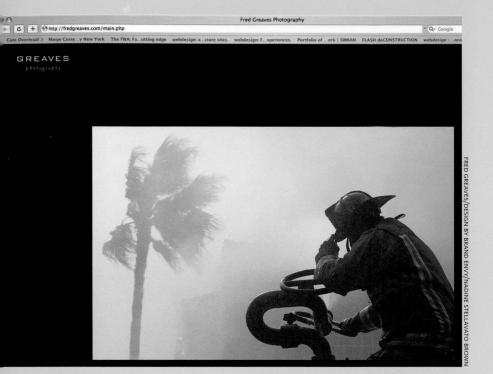

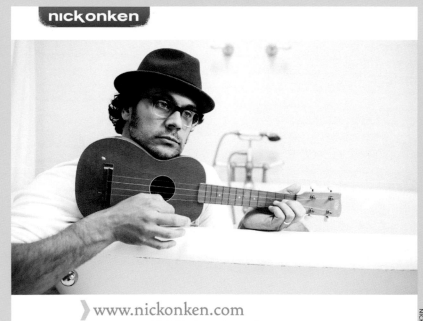

> www.nickonken.com
info@nickonken.com | +1.310.467.7477

CONTENTS

FOREWORD

BY LOU LESKO

Years ago, I had a conversation with a wealthy elderly woman in New Orleans who was drinking me under the table. She imparted to me a wise phrase in an attempt to put my weak financial status as a photographer into perspective: "Only God is multitalented enough to not have to delegate." Being the humble young man that I was, I dismissed her comment and thought about seeking other drinking partners who would be a little less honest about the reality of my career status.

Somewhere in the annals of history, photographers became associated with coffeehouses, martinis, glamorous lives, and insufficient funds. We have our brethren in other creative genres to blame for that. No one ever talks about the well-to-do writer or artist making an impact; they talk about the insane, impoverished, absinthe-drinking genius drawing upon his or her destitution for the inspiration of great works. Even though photography is a creative genre of the same ilk as painting or writing, shooting pictures for a living is different.

Photography has more commercial viability than any other art form. We can pursue any of the various subgenres within the photography world and make a buck while also producing wonderfully obscure artistic works to feed our tortured genius and to have a reason to talk beautiful men and women out of their clothes. So, given that I work in a profession with so much profit potential, I have always wondered why I spent my twenties excusing myself to restaurant bathrooms in order to secretly call my credit card issuers to see if I had enough on the card to pay for the pending bill.

We are blinded by our own ego. Photography is a profession of many hats. We must be, among other things, great visual storytellers, technology experts, travel mavens, and politicians—all this in an industry that requires us to manifest these skills on the fly. So why wouldn't we assume that we're also brilliant marketers and businesspeople? The problem is that we do assume we're brilliant marketers and businesspeople. Consequently, we blame the fact that we're not reaching our fiscal potential on horoscopes, global warming, and alien visitations.

The Photographer's Survival Guide is a lot like a sober version of my conversation with the elderly woman from New Orleans—really smart advice that we don't want to hear because we think we already know it all. What we know is photography. The authors of *The Photographer's Survival Guide*, Suzanne Sease and Amanda Sosa Stone, know the business of photography. Ms. Sease and Ms. Sosa Stone have taken decades of experience, most of which is from the other side of the ad agency door, and put it into a language that we photographers can understand and easily implement into our careers.

If you are a photographer who has made superabundant amounts of money in your profession, then put this book down and buy me a Ferrari. But if you are looking to realize more profits from your passion and inherent talent as photographer, then *The Photographer's Survival Guide* will inspire you to think differently about the way you approach the business side of your career.

ACKNOWLEDGMENTS

A huge "thank you!" to all of our contributors, whose willingness to help educate others is forever appreciated. For providing their insights, based on their years in the business, and for allowing us to use material that has been published elsewhere, we thank Kat Dalager, Ellen Boughn, Rob Haggart, Nadine Stellavato Brown, Lou Lesko, Mary Virginia Swanson, and Tamera Haney. Our book is enriched by the unique voices of Nick Onken, Ray Behar, Carolee Coker, Jessica Hoffman, Angela Lewis Reid, Tiffany Correa, Jackie Contee, Doug Truppe, Rosie Anderson, and Gregg Lhotsky, who provided special words of wisdom. Special thanks to Keith Gentile at Agency Access—his support is neverending.

We would like to thank our families, who have been there with us through the writing of this book and have supported us as we traveled around the country. Suzanne thanks her husband, Doug, and her two sons, Aaron and Spencer. She would also like to thank all of the wonderful clients and friends who helped with images, quotes, and information. Suzanne feels so fortunate to have all of these people in her life. Amanda thanks her husband, Jedidiah, for his love, support, and patience, and her parents, whose guidance has helped her on this path. To her grandparents, siblings, and in-laws—thanks for always being such a fantastic support system. She is grateful to all the clients who have helped her get to this point in her career. Lastly, a heartfelt thanks to Elyse Weissberg's family—Hannah, Sonny, and Ted Spero—whose support has been a guiding light.

The world of commercial photography is changing dramatically. With so much going on today—the dot-com market going bust, big changes in our economy, the issue of stock vs. assignment—how is a photographer to keep up? With *The Photographer's Survival Guide* we present a path to a solution. This book is for all levels of photographers—from those who are just starting out to those who have been in the business for years and want to move to the next level.

This guide covers topics from everyday photography-business basics to those uncomfortable "What do I do?" moments—real-life situations that can arise in the industry. The chapters include information on who to market to, how to present work, how to assess the expectations of a client, invoicing, when to expect to be paid when you finish a project, and everything in between, including discussion of and guidance on those "What do I do?" moments.

The Photographer's Survival Guide is also a resource that provides helpful information, including a glossary of usage terms and names of portfolio makers, website builders, printers, and database services. It even includes deadlines for important assignment award shows and photography contests.

The CD that is packaged with the book includes 21 forms and templates for documents that photographers can use in their planning and their work with clients (Appendix B gives instructions for using them).

The bottom line: This book is *the* photographer's guide to survival.

The Authors

We were introduced through Keith Gentile at Agency Access, and it was instant chemistry from the first moment we spoke on the phone. We immediately came up with the idea to present a seminar together. Now, for several weeks each year, we travel around North America presenting our "Survival Guide for Today's Market" seminar, for which we created a guide in book form that led to this book.

We have also been blessed to work as co-consultants and, with Brand Envy's Nadine Stellavato Brown, to revamp the assignment division of National Geographic Images. Check it out at www.nationalgeographi-cassignment.com.

One thing we both say: "We are an egoless team, we finish each other's sentences, and we are both in the business to help. It's nice to have a partner and friend in the business."

SUZANNE SEASE

When Suzanne was asked to be in the *Photo District News* portfolio makeover issue, which highlighted the work of only five consultants with a client, she felt that her decision to leave her position as senior art buyer at the Martin Agency had finally paid off.

Suzanne Sease (with youngest child, Spencer).

At first, having spent 12 years working to establish the agency's art buying department and working with the best photographers in the world, it was scary for her to leave. After working one on one with her clients at Martin—accounts like Saab, Mercedes-Benz, Vassarette Lingerie, Healthtex, Wrangler Jeans, Bank One, Residence Inn, Finlandia Vodka, Rémy Martin Cognac, and Seiko International—Suzanne had the opportunity to work with Kaplan-Thaler, an advertising agency in New York City, on such important accounts as Clairol

Herbal Essence and AFLAC, and then the in-house, corporate side of Capital One.

All of these experiences helped her understand the current market, and today nothing makes her happier and more fulfilled than the success of her photography clients. Now a creative consultant, Suzanne works with photographers from around the world who want an inside perspective on advertising agencies. She enjoys getting involved in every aspect of a photographer's business, from portfolios, promotional mailers, and websites to estimates and invoices. Her focus is on helping clients assemble more effective portfolios and marketing materials.

When a client lands an account he never thought he could, Suzanne is happy. When she picks a selection of images for an award show competition for a client, including the *Communication Arts (CA) Photography Annual*, and the client is accepted for the first time in his or her career, she is happy. When her clients remember why they got into the business in the first place—their love for the art of photography—she is happy.

Suzanne has been a panelist and speaker for such organizations as PhotoExpo, Advertising Photographers of America, American Society of Media Photographers, and Black Book. She has also contributed to several articles, including "Ask the Expert," "Portfolio Makeover," and "The Art of the Estimate," in *Photo District News*. She holds a Bachelor of Fine Arts degree from Virginia Commonwealth University.

Suzanne can be reached via e-mail at suzanne.sease@verizon.net and by phone at 804-741-9070.

AMANDA SOSA STONE

Amanda Sosa Stone has a degree in photography from the Southeast Center for Photographic Studies. With the understanding that she did not want to become a photographer, after graduating she moved to New York City to pursue a career in the industry. Amanda studied under Elyse Weissberg, a photographer's representative and creative consultant who became an industry icon.

Amanda Sosa Stone.

With the knowledge she gained from working with Elyse, Amanda went to work as an art buyer for the ad agency Foote, Cone & Belding in New York City. In 2002, she moved to Orlando to be closer to her family and to enjoy the weather and overall atmosphere of the area, and was able to continue working for FCB-NY (now Draft FCB) from her home there. This allowed her some extra time to do the things that she loves, including consultant work.

In January 2005, Amanda left FCB to pursue a full-time freelance consulting career. She now travels frequently, giving seminars and consulting with photographers nationwide. The founder of the online resource guide ShootinFlorida.com, she continually strives to raise the bar of excellence in our industry.

Amanda was the photo editor for *Successful Self-Promotion for Photographers*, a book by Elyse Weissberg, which was released in February 2004.

Amanda can be reached via e-mail at amanda@sosastone.com and by phone at 407-849-6660.

01

ESTABLISHING YOUR STYLE

WORST-CASE SCENARIO: YOU PRESENT YOUR PORTFOLIO FOR REVIEW AND THE POTENTIAL CLIENT ASKS, "SO WHAT TYPE OF WORK DO YOU DO?" YOU DON'T KNOW HOW TO RESPOND.

WORST-CASE SCENARIO: YOUR PORTFOLIO IS ENTIRELY SFI F-PRODUCED AND THE VIEWER ASKS, "SO WHAT WAS THIS SHOT FOR?"

Honesty is always the best policy, so in both scenarios your answer should be something like, "I have found that most clients did not hire me for the work that I love to shoot, so I decided to shoot a body of work that reflects a wider range of my talents."

The lesson from these two scenarios is that you should shoot what you love. What you shoot should be an extension of who you are as an artist.

This chapter is about your identity as a photographer—what it is that is uniquely you. Once you understand your uniqueness, you are on the way to developing your style.

What Is a Style?

If you were asked to describe your work, what would you say? I shoot food? I shoot still life? I shoot people? I shoot lifestyle?

Even if you are a generalist who shoots in a variety of genres, all of your work must feel the same—the viewer must sense that the same person shot all of the work. You can shoot products, food, locations, and people, but the images must all be unified by your personal style.

A style is what makes you unique. It separates you from your competition. According to Ray Behar, Creative Director at Draft FCB, "Style is a photographer's visual signature that is different from any other. It's akin to a fingerprint or DNA." Ray goes on to reflect on the importance of a photographer's style: "In my mind, style is as important to a photographer as his production skills. What makes me choose a photographer is that his overall talent best expresses the idea I want to shoot."

Carolee Coker, Art Director at IMI, considers style from another perspective: "Style is what makes you get that phone call."

AUGUST BRADLEY

AUGUST BRADLEY

The most important element for success is a style that is distinctly yours. August Bradley spent time creating his style before marketing his work.

- -

AUGUST BRADLEY

The Benefits of Having a Style

Having a style means that you stand for something. A style helps the creative person in an organization hire you with the confidence that you will successfully execute their concept.

Think about it: When you shoot what everyone else shoots, you are only increasing your competition. If your images look like everyone else's, your work gets less attention. But when your work is unique—that is, if it has a distinctive style—it stands out and that creative person is going to want only you.

If a company is looking for someone to shoot its executives on location around the world and you offer what everyone does, it is 100 percent guaranteed that the client will opt for the lowest bid. But if you offer the ability to capture executives in a natural manner in their own environment and the client wants to stand above his competition, he will pick you and work with you on the budget.

Ways to Achieve Your Own Style

The pressure to perform and create something wonderful for your portfolio can be great. However, if you sit and worry and try to figure out some fabulous shots you could make and then stew and worry some more, you will not be able to create freely.

Instead, shoot, shoot, shoot—and capture something special. Don't think about your portfolio. Just shoot what you love instead of shooting for your portfolio.

James Quantz works in a special style that takes a subject to an elevated level.

>>

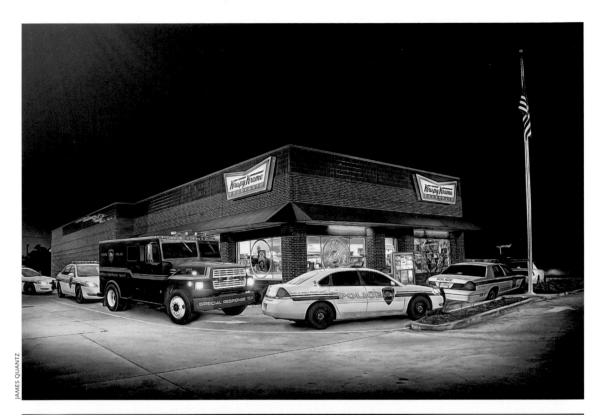

JAMES QUANTZ

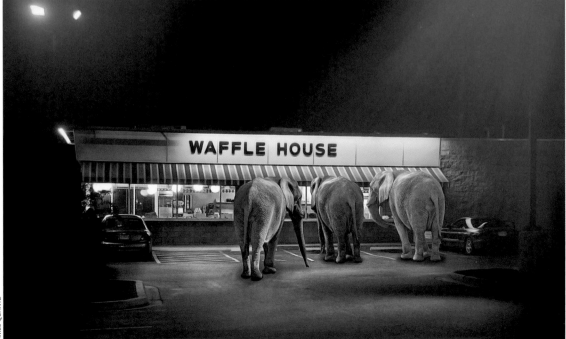

JAMES QUANTZ

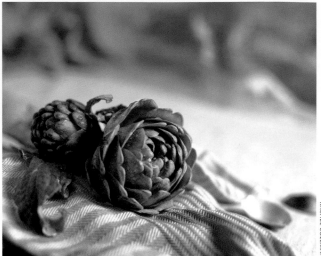

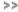

Look around and find an everyday object that inspires you to create a beautiful image.

Rachel Coleman takes an ordinary object and creates something special. In this situation she shoots something that is both elegant and simple.

>>

Here are some ideas to help you get motivated:

>> *Look through a magazine and be inspired.* The photographic topics, concepts, and styles that appear in magazines are what is happening in today's market. Look at the layouts and the production values and try to replicate them—but with your own vision and style.

>> *Go out and look around.* Find an object and let it inspire you. Go to the mall or walk down a busy street and look at the signs and billboards around you—these are the materials that companies are using to advertise to consumers. A great deal of test marketing and focus group work went into those displays to get folks to buy.

>> *Regularly jot down ideas in a notebook or carry a small point-and-shoot camera.* Capture moments that you can re-create later in a set-up situation. We call these "free images" or "gifts from the photo gods."

>> *Capture any scenarios that strike you,* ranging from a child having a temper tantrum to the gentleness of a youngster reacting to a grandparent, or even a beautifully prepared meal in a restaurant. Go out and shoot everyday life.

>> *If you come across an item that you think will one day add to a really cool shot, buy it and hold on to it.* A funky lamp can really spice up the background of a shot. Find a mask to add that "something extra" to a

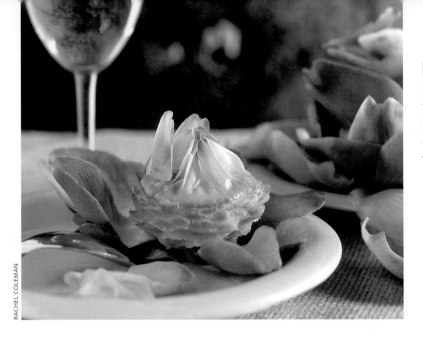

RACHEL COLEMAN

In this shot, Rachel takes her process further. She adds a sexy element, removing the leaves to show the heart of the artichoke.

- -

shot and create a mood. Use a plain, old, everyday piece of pottery to hold a simple food item and make a shot stronger.

» *Work with a talented crew.* Collaborating with stylists and models—people you or your friends know or whom you hook up with through networking—can help establish shots for your portfolio that look well produced. Many crews will work on the barter system, trading their time for images to use in their own books.

When you see this antique menu (a campy photo of dishes of food imprinted on a tray), what comes to your mind? Are you inspired to shoot food styled as though it's from this era—maybe eggs and bacon making a smiley face or a '50s-style diner with a waitress dressed to match? Look at things around you and allow them to inspire you with ideas for photographs.

- -

Find a subject while you are out and about, let that scenario provoke an emotion in you, then re-create that emotion.

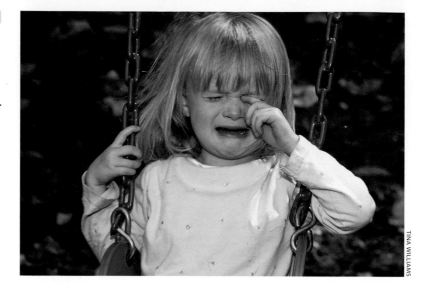

TINA WILLIAMS

Questions to Ask Yourself

Sometimes a little honest dialogue with yourself can help clarify what you need to do to move forward. Start with these questions:

WHO AM I?

Photographers generally come from one of two backgrounds. They either went to photography school or are self-taught. For doing studio work, no one is better just because they went to photography school. Many self-taught photographers are extremely successful.

An art buyer will never ask you for a resume or a diploma from the school you attended. Your work as shown in your portfolio and on your website is your resume.

When Colby Lysne wanted to break away from assisting and shoot full-time, he worked on his portfolio before approaching the market. He created a body of work that represented him and what he wanted to be hired to shoot. Although he wondered whether he could do corporate work, he listened to his consultant and stayed true to what he wanted to do. Currently Colby is represented by a national rep firm and getting the assignments he wants to do—in other words, he is getting paid to do what he loves.

>>

COLBY LYSNE

COLBY LYSNE

COLBY LYSNE

COLBY LYSNE

WHAT DO I WANT OUT OF THIS CAREER?

If your answer to this question is, "A lot of money," change careers immediately. Most successful photographers are in the business mainly because they love the art of photography, and their passion is evident in their images. This is what really brings in the business. People want to work with positive and passionate photographers. Remember: Photography is an art form, and people hire you for your artistic vision.

AM I WHERE I WANT TO BE?

If your answer is no, then you need to assess where you want to go and how to make the changes that will get you there. Who do you ask? Friends? Will they really be honest? Your spouse? Are they as frustrated as you are with your career status, and will they respond honestly?

› FORMS AND TEMPLATES FOR YOUR USE

Throughout this book you'll find images of and discussions about documents that photographers can use in their planning (worksheets, a budget template, a calendar) or their work with clients (an estimate questionnaire, property and talent releases, a budget overage report). These, plus many more—a total of 21 forms and templates—are included on the CD that is packaged with this book. See Appendix B for a list of all the documents on the CD and concise instructions about how to use them.

PHOTOGRAPHER WORKSHEET Date _____

Where was I? _____
Where am I now? _____
Where do I want to go? _____

Budget for the year: $_____
Goal timeline start date: _____
Goal completion date: _____

Do I need assistance: yes / no
If yes, who? _____

Do I have a marketing plan in place? yes / no
Do I have a database? yes / no
If no, who will I purchase one from? _____

Do I have my arsenal of answers/resources prepared?

 ❑ Day rate (editorial and commercial)
 ❑ Forms ready (estimate template, estimate questionnaire, etc.)
 ❑ Crew researched (producers, assistants, stylists, etc.)
 ❑ Industry resources (negotiator, consultant, etc.)

Previous lessons to take forward: _____

What do I need?
 ❑ Portfolio
 ❑ Website
 ❑ Brand design
 ❑ Marketing plan
 ❑ Database
 ❑ Creative outlets
 ❑ Support

The questions on this worksheet—included on the CD packaged with this book—may help you focus on what you need to do to get your career on track.

A Consultant Can Help

A *consultant* is a creative person who helps photographers in many different areas of their work. What does a photographic consultant do? Perhaps most important, a consultant will guide you as you work to establish your own, distinctive style.

A consultant also will typically help select images for your website, printed portfolio, e-mail images, and mailers, and guide you in acquiring or compiling a database and creating a plan for your marketing.

A few words about two other types of support professionals a photographer can hire:

>> *Artist's representatives* work to get their clients assignments. They market, represent, and estimate jobs, and some reps even final-bill the jobs their clients do. In return for the rep's time and marketing expertise, photographers give them a percentage of their creative fees from assignments and, of course, pay the costs incurred by the rep for promotional pieces, couriers and shipping, and travel.

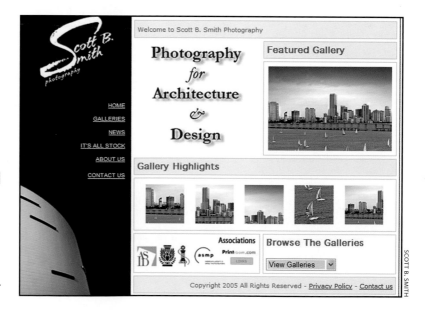

Scott Smith's existing logo and website presentation looked dated, as though they were from the 1980s—not the look he wanted. It's important to look around and see what is current.

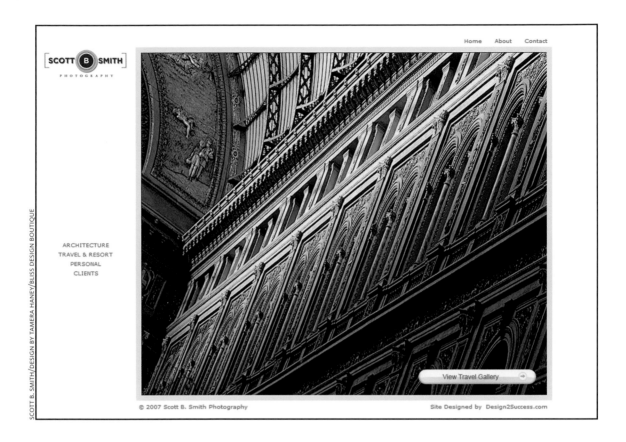

>> *Designers,* usually hired on a freelance basis, create marketing brands and design approaches for photographers. You can hire them for a particular project or work with them on a retainer basis, which means you can call on them for any or all of your design needs at any time.

While consultants can differ in their styles and approaches, in the end a consultant should give both creative and marketing advice to help you move your career forward. Even if you have an agent or work with a designer, a consultant can be an asset to your marketing and portfolio and website presentations.

The best consultants are the ones who have been in a creative field—as an art buyer, an art director, or a photographer's rep—so that they

When Scott Smith worked with designer Tamera Haney, this was the outcome—a great site-opener screen that is fresh and clean and invites the viewer in. Scott's logo now looks current. His site show-cases his work in a manner that meets industry standards for style and content.

understand what photographers need to do to make their work stand out, and then how to market themselves properly.

Some consultants are better than others at counseling you on what direction to take in your career, while others are strictly editors. Yet other consultants may even coach you on what to shoot to extend your portfolio.

Before you hire someone to help you with your career, interview several candidates to find the one you think will work best with your needs and personality. It's like any other close relationship: Will the two of you be a good fit? While some consultants will give you details about their past clients, others don't like to "kiss and tell." Even without trying to elicit specific information, you should ask about their past successes and request examples of those successes.

Also ask about a consultant's experience with your style of photography. How will he or she be able to help you? If the response is "That will cost you," you have to decide whether you want to continue the conversation. Prospective consultants should be willing to have a five- to ten-minute phone chat with you about your work.

Two of the most important questions a consultant should ask are, "What made you call and what do you want to change?" Let's face it, you wouldn't be calling if you didn't need to change something.

One of the best ways to gauge where you are right now is to sit down and ask yourself these questions: Where have I been? Where am I now? Where do I want to go? The answers will help you and the consultant of your choice get you on the right path.

Do you have the capital to make the leap? Are you willing to invest in a brand identity for your portfolio and website and promotional materials? Consultants' fees vary. You could spend anywhere from $200 (for a

quick evaluation of your current website) to $2,000 for help designing a new site, creating new branding, and carefully guiding you in creating new mailing materials. We have actually heard of a photographer who spent more than $5,000 for the services of a consultant.

There are many consultants all over country who offer a variety of views and experiences that may be of benefit to you. Here, starting with our own names, is a list of consultants we recommend.

>> Amanda Sosa Stone. Resource guide owner, former rep, art buyer, and assistant to Elyse Weissberg. www.sosastone.com

>> Suzanne Sease. Former art buyer at several regional, national, and international ad agencies and in-house corporations. www.suzannesease.com

>> Susan Baraz and Rhoni Epstein. www.phototherapists.com

>> Ellen Boughn. Also a stock consultant. www.ellenboughn.com

>> Leslie Burns-Dell'Acqua. Former rep. www.burnsautoparts.com

>> Louisa Curtis. Former source book rep. www.chatterboxenterprises.com

>> Deanne Delbridge. www.deannedelbridge.com

>> Selina Maitreya. www.1portauthority.com

>> Andrea Maurio. Editorial consultant. www.andreamaurio.com

>> Carolyn Potts. www.cpotts.com

>> Monica Suder. Great career coach. www.monicasuder.com

>> Ian Summers. Former creative director. www.heartstorming.com

>> Debra Weiss. www.debraweiss.com

>> Allegra Wilde. www.allegrawilde.com

Nick Onken is constantly shooting. Regardless of what he shoots, his style crosses over into the many categories he features on his website.

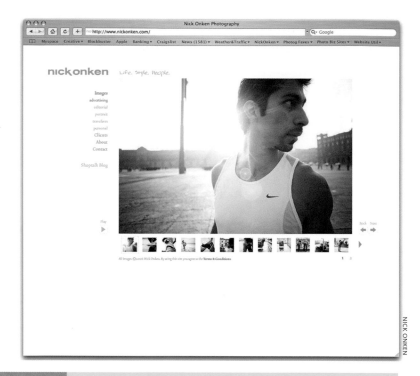

>> Question

How have you stayed positive for the last two years?

>> Answer

I stay positive with encouragement from my consultant and by shooting new work all the time. Shooting new work keeps me fresh, inspired, and creatively fulfilled. Of course, we have to make money and pay the bills, but being creatively fulfilled is the main reason we should be doing this job. If we do that right, we will get hired for jobs that give us that creative satisfaction. Having that as a goal to push for is the best way for me to stay positive.

—NICK ONKEN
UP-AND-COMING PHOTOGRAPHER WHO HAS LANDED
A NIKE CAMPAIGN AND AN INTERNATIONAL REP

NICK ONKEN

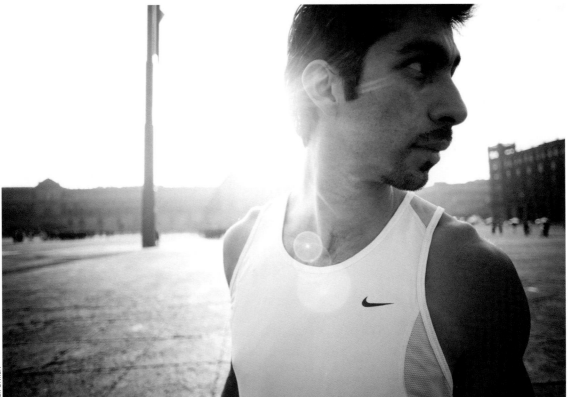

NICK ONKEN

Have you seen any direct impact on the work you get from the marketing you do?

Marketing has taken me to the next level. I've been doing regular e-promo campaigns consistently, as well as a few direct-mail campaigns. I think it gets your name out there more in a branding perspective. The more people see your name, the more they will start to recognize it. In addition to mass marketing, I regularly schedule meetings and try to meet at least two new industry people a month and show them my book.

—NICK ONKEN, PHOTOGRAPHER

> SLOW AND STEADY

Being properly prepared means being consistent for the first year. You know the old saying: Slow and steady wins the race. Spread out your efforts, and don't do everything all at once. Let your budget dictate what you can afford to do. Once you start marketing, plan to continue marketing for the rest of your career.

nickonken

NICK ONKEN

〉 www.nickonken.com
info@nickonken.com | +1.310.467.7477

Nick makes sure his images work with his branding. He e-mails images that reflect the work he is trying to get.

〉〉 Question

How does someone who is unknown get work?

〉〉 Answer

Establish relationships with art directors and art producers. Take the time to do some research to find clients you think you would match well with, then target that organization and those who work there. Get yourself some PR through your name being shown in editorial work and award shows and contests. Getting your name out there is so important, yet for some people it seems to be an afterthought. One person sent me work I loved and didn't even include his or her name. And including your name on your portfolio as a handwritten scrawl of squiggles doesn't help. That name is not going to be burned into my mind.

—JESSICA HOFFMAN, SENIOR INTEGRATED ART PRODUCER,
CRISPIN PORTER + BOGUSKY, BOULDER

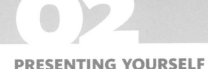

PRESENTING YOURSELF

WORST-CASE SCENARIO: A CLIENT CALLS IN YOUR BOOK AND YOU DON'T HAVE ONE. YOU SCRAMBLE AND SEND A BOTCHED BOOK.

WORST-CASE SCENARIO: YOU DESIGN A REALLY COOL, UNIQUELY SIZED PORTFOLIO, BUT IT DOESN'T FIT INTO A FEDEX BOX OR OTHER STANDARD SHIPPING CASE. IT COMES BACK MANGLED.

WORST-CASE SCENARIO: YOU WANT YOUR IMAGES TO STAND OUT, SO YOU ORDER A 16" x 20" PORTFOLIO. VIEWERS HATE IT.

You should have a portfolio that reflects your style prepared and ready for the moment when a client calls. If the call comes and you don't have a book ready, try to buy some time. Say, "All my books are out, but I'll try to retrieve one. What is your deadline?"

If a client asks for specific imagery, create a gallery on your website or submit a mini-portfolio of prints to be viewed alongside your "style book."

Think about how your portfolio will ship. One super-cool book with "fins" like a Cadillac lasted for only one shipment. An assistant preparing your portfolio for return may not consider how precious it is.

Size does matter. The average art director, buyer, or designer works in a cubicle. When your opened portfolio spans 32" and knocks over everything on the desk, you have not made a good first impression.

You Need a Website and a Portfolio

There was a time when photographers presented themselves exclusively with portfolios—formal book presentations of their most representative work. But that was before the Internet became a driving influence in all of our lives.

Websites are a must in today's market. Having a printed portfolio is secondary, but the answer—after much debate—is that it is still a necessity. We have talked to hundreds of your potential clients, and they all say a book is crucial, especially for presenting you to their clients as they try to assign a project.

And one other thing is certain: Today, a photographer without a website is at a distinct disadvantage. About 90 percent of the time photographers are being hired from their websites, so having one is crucial—it's not an option, it's *a must*.

Jeff Moore used a blanket template Web design that was boring and didn't showcase his work as it should be seen. We call this lost real estate.

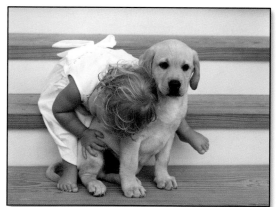

A website allows viewers to view your work and identify you as a potential vendor before calling in your book (if needed). Usually these days if your book is called in, it means you are a good contender for an assignment.

Beginning photographers often ask, "How much similarity should there be between my website and my portfolio?" The answer is that the two should complement one another stylistically and show similar content and images, but they do not have to be identical.

A website portfolio should contain between 15 and 30 photographs per gallery (you have only a matter of seconds to sell yourself on your site, which a viewer can click out of in an instant), while a book portfolio can contain more—anywhere from 40 to 80 images.

Opening a portfolio book is more of a commitment—someone who sits down with your book will probably stick with it for the amount of time it takes to page or flip through a few dozen of your photographs.

And, of course, both types of portfolio—Web and book—should display the best of your work.

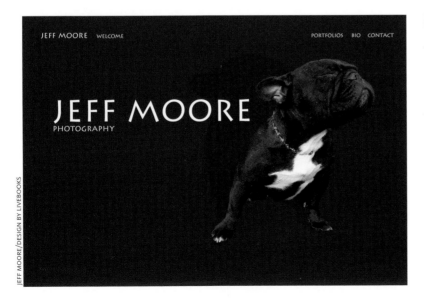

JEFF MOORE/DESIGN BY LIVEBOOKS

Jeff invested in liveBooks (www.live-books.com), and look at the difference. His image is now bold and inviting and makes the viewer want to see more.

On his old site, Richard Radstone wanted to show a lot of everything and ended up choosing categories that confused the viewer. Be specific about what you are showing, and don't use titles and icons for the various subsections that only you would understand.

>>

Richard worked with Nadine Stellavato Brown, an amazing designer, who branded Richard and, together with Suzanne, streamlined the presentation of what he does best.

v
v

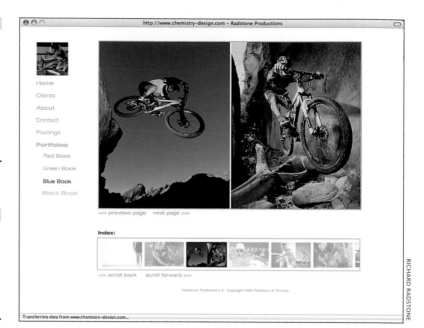

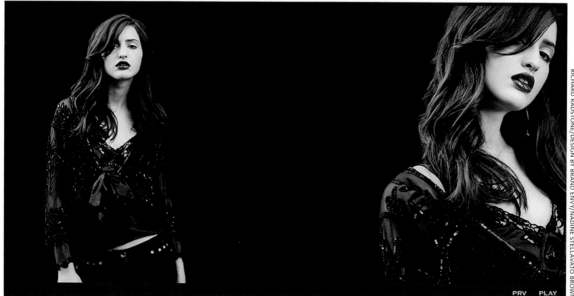

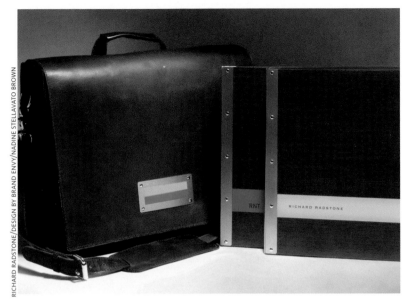

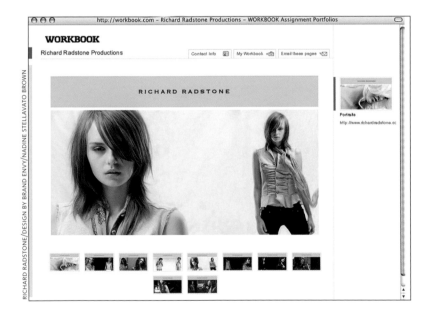

Nadine continued the branding from Richard's website to his portfolio. The new branding is a part of all of Richard's materials—from stationery, mailers, portfolio, and website to his portfolio case.

Richard's brand was designed to cross over into other marketing arenas. The graphic shown here was Richard's portfolio as it appeared on workbook.com (see page 110).

Creating Budgets

Before we get into the nitty-gritty of creating your website and portfolio, let's look at how much these things cost.

ESTIMATING PORTFOLIO COSTS

Portfolio covers, paper, and ink typically cost anywhere from $850 to $1,500, but you could spend up to $5,000 for a fancy book or as little as $350 for an off-the-shelf portfolio.

We recommend spending the money and doing it right: Have a designer lay out your book. We highly recommend Nadine Stellavato Brown at Brand Envy (go to www.lost-luggage.com's Brand Envy section). Because she and her husband own a successful portfolio business, she understands interior and exterior portfolio development. Nadine is the "portfolio whisperer."

WHAT WILL A WEBSITE COST?

Estimate somewhere between $1,500 and $6,000. The number will depend on what you are looking for. Some companies may offer the same navigational program to all their clients (a template); www.bludomain.com, for example, offers very inexpensive website templates. Other design firms or website programmers can create a customized site just for you.

PLANNING FOR PROMOTIONS

A good estimate for the cost of producing a no-frills mailer (design and printing, including bulk-rate postage) is $1 per card. The price goes up

for multipart cards, bi-fold or tri-fold panels, expensive die-cuts, over-size cards, etc.

ROUGH OUT AN IDEA OF YOUR ANNUAL MARKETING EXPENSES

When deciding what to spend for your marketing, make a yearly budget for yourself. You need to have a good basis for deciding where your marketing dollars should go, so as you read on in this book, think about the activities you may want to invest in.

Once you've determined the yearly costs for marketing activities you'd like to do, divide the total by 12 months to make it easier to see whether you can afford what you want to do.

BUDGETING THE TIME YOU'LL SPEND ON YOUR BOOK AND WEBSITE

You've considered the financial angle. Now you have to decide whether you have the time it will take to create a website and a portfolio. Here are our estimates for the amount of time you'll probably have to spend on four different activities.

> *Ordering Books and Printing Your Images Yourself:*
 Two Weeks to Six Months
You'll need to take some time to look over the portfolio book and shipping case options. You can buy one off the shelf, ready to use. If you choose to order the book, you'll have to wait for it and the shipping case to arrive. Likewise, deciding on and ordering paper and waiting for it to arrive takes time.

Here's a sample budget. The numbers are hypothetical and do not reflect everyone's budget, and of course vendors' costs may vary. See Appendix B for a downloadable version of this form that you can use to create your budget.

ANNUAL BUDGET

	Estimate
Website revamp	$2,000.00
Online resources	$0.00
Organization memberships – ASMP	$350.00
Web hosting	$100.00
Brand design	$3,000.00
Portfolio	$600.00
Support portfolio (mini-portfolio)	$200.00
Agency Access membership	$925.00
Agency Access 12k bundle	$600.00
Printed mailer (estimate $1 per name min.)	$0.00
Follow-up mailer (2% of database x mailings)	$500.00
Campaign manager	$550.00
Wise Elephant (calling service)	$500.00
Holiday gifts	$1,000.00
Consulting	$850.00
Stock consultant	$400.00
Travel	$1,000.00
Dream clients	$500.00
Contests	$200.00
TOTAL	**$13,275.00**

These numbers are shown as examples only.
Please research prior to setting your budget.

Once you receive the materials, you have to get your printer and programs set up to work together perfectly. (If you don't have a printer that can perform with the quality you want for your portfolio, companies like www.pushdotstudio.com can print your portfolio pages for you.)

Printing a series of images, including full drying time, or having them printed, takes a while. Then you have to put the book together.

› *Online Design and Printing: Overnight to Two Weeks*

This is a great solution if you have a limited budget or don't have enough time to sit down and print a traditional book. There are many vendors who can create many different types of books; these volumes are usually perfect-bound books, with the option of a hard or soft cover. See pages 47–48 for more on ordering these books.

> *Working with a Designer to Lay Out Your Book: Two Weeks*
> *to Six Months*

While working with a designer can be a lot of fun, it can also be daunting. A designer can help you select the images you will include, the sequence in which they will appear, and the look of the cover, including color, fabric, and the type treatment for your name and contact info.

A good designer will give you multiple options to select from. Deciding on the final design can be difficult. But in the end, a good designer will deliver the look and feel that your work deserves. Generally, a book that has been shaped by a designer allows you to quickly and successfully speak (visually and conceptually) to your potential creative clients.

> *Creating a Website*

Creating a website can take anywhere from two weeks (for a simple template site, if the images have been edited and are ready to upload) to six months to a year (for a custom design and image editing and sequencing). Make sure your site reflects the work you are doing now and that it is flexible enough to allow easy editing for the future. We strongly recommend that you be able to do routine editing of your site yourself without needing to go back to the site designer.

Editing Your Work

If you hire a designer (more on this at the end of the chapter), he or she should edit your photographs. If you edit your images yourself, either review your work by mounting it on a wall and looking at it for at least a week, or view it in a slide show presentation to get the feel that someone would when flipping through a book.

Most Mac computers come with iPhoto, which allows you to create a digital mock-up "portfolio" (with a PC, use PowerPoint). This program allows you to review your images as spreads with single or multiple

images. The only downside is that iPhoto will crop your images, so use it just for reference and reviewing your images in a sequence.

Another editing tip is to find your "hero" or "killer" shot (your best shot). Ask an industry contact to make this recommendation, and then use that image as the standard for your entire body of work. If a shot equals or comes near to the hero shot, then it's a keeper. If a shot does not compare to your best work, then you know to throw it out of your portfolio.

This contact sheet shows a portion of Justin Guariglia's work and the successful flow of images he created. Each image complements the next, and they all work together to build a cohesive portfolio that looks amazing.

- -

76437922 1062911 B0119P 0271

55898361 761072 77163298

57504384 761068 962619

Photographers have a hard time letting go of images because each one is personal. Appreciate the shot and the moment that created it and feel free to keep the image in your personal portfolio, but do not let emotion dictate your editing. You must try to be neutral.

Look at your work as a whole, not as individual images. Taken as a whole, your book should tell the story of who you are stylistically.

Websites

Your website is effectively the key to whether your printed portfolio will be called in. Here are a few basic tips for setting up an attractive and compelling site.

The first five images that appear on your site must be strong enough to define and sell your style. Within the first five images, you have either won or lost your potential client.

Your website needs to load quickly. Too many bells and whistles will slow it down, and you will lose potential viewers.

It's annoying to ask the viewer to agree to your terms. A website is one place where the two-second rule definitely applies: Creative people want to go to your site and see work within two seconds. Seconds in cyber time equal minutes in real time. Use those seconds wisely.

RULES OF THUMB

Make sure your site's home page will load in its entirety on one screen, within the frame of a standard 15" monitor. The viewer should not have to scroll down to see your images or your entire home page. The

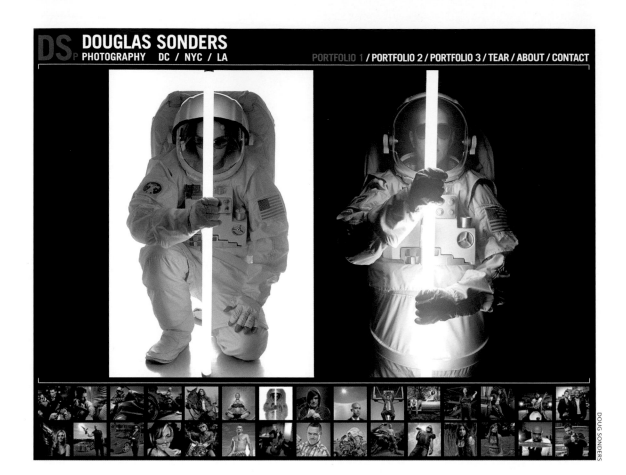

You can make a great site on your own. Doug Sonders used his computer skills with Adobe Dreamweaver and Fireworks to create his own website. Doug uses thumbnails along the bottom of the screen; as you "mouse" over them individual images are enlarged in the space above.

majority of your potential client viewers use laptops. Although some may have access to an additional monitor to view files, you can't be sure of this, so prepare accordingly.

Test your site using all browsers—Internet Explorer, Safari, Netscape, Mozilla Firefox, Flock, Opera, AOL Explorer, Google Chrome, and others as they become popular—that are compatible with Macs and PCs.

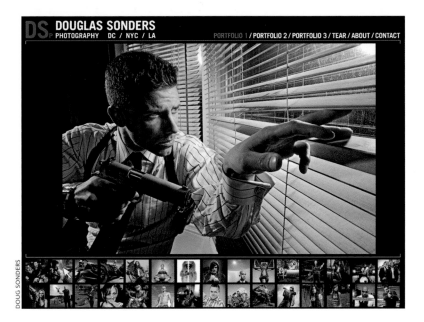

You want every computer user to have access to your site, and it is important that every computer display your site in the best possible presentation.

While a website may look good on your computer, it can look very different on another. Have many people test your site before you officially launch it.

Here are other important rules of thumb as you plan your website.

>> It should be user-friendly—clean (that is, simple, not "busy," with not too much visual noise or wording) and fast, with quick downloading. Navigational elements need to be easy to find. Using strange icons will confuse viewers, who should be able to proceed to the next image, choose another section, or get "home" from wherever they are on the site with just one click.
>> It should have an aesthetically pleasing design. Remember: You are appealing to creative people who are designers themselves. They like to look at something that's pleasing to the eye.

>> Try to make your site speak the language of your potential clients. Don't include weird categories. Clients are going to your site to look at images for a certain project, and strange categories will just make it harder for them to find what they are looking for—and easy for them to decide to click out of your site.

>> Make sure you show images that represent the work you want to be hired to shoot. Throwing everything you have shot onto your site will confuse the viewer about who you are as a photographer.

>> Provide accurate contact information, and make your phone number and e-mail address easy to find. Include a quick, one-click, direct e-mail link. Don't make a potential client cut and paste in order to contact you.

>> Do not use music. Imagine having someone go to your site only to have music suddenly blare through all the cubicles in the office. Viewers who hear loud or jarring music may quickly close out of your site to stop the music, and you may have just lost a potential client. Music *may* be acceptable on the sites of wedding or certain kinds of consumer photographers, but in general, music creates an emotion, and you do not want to try to control your viewers' emotions.

>> Don't include "commitment pages," sections where readers have to agree not to steal your images. People who do not accept the copyright laws are going to steal no matter what. You are not targeting thieves, so do not insult art buyers and design directors by cautioning them not to steal from you.

> **INDUSTRY FEEDBACK**

In a recent nationwide survey about websites, art buyers and art directors unanimously agreed that music, terms, and slow loading are major deal breakers.

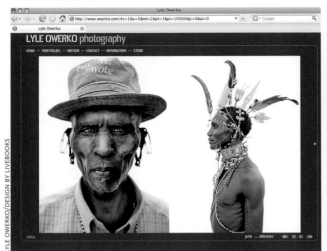

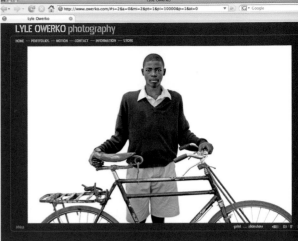

LYLE OWERKO/DESIGN BY LIVEBOOKS

SITE-BUILDING OPTIONS

There are many affordable templates available that are much more cost-effective than a customized site. But do in-depth research—those that are the least expensive may be also be limiting in their scope.

Building a website may mean that you'll need to sharpen your computer skills. If you need to learn a new program or two, we recommend www.lynda.com.

> *Custom Sites*
Representing yourself with a custom site allows you to show your distinctive style while allowing the viewer to navigate through a fresh perspective—yours—and experience a new navigational journey.

Three of the companies we recommend for creating custom websites are Brand Envy (www.brand-envy.com), pH3 (www.pH3.us), and Bliss Design Boutique (www.blissdesignboutique.com).

Companies like liveBooks help photographers create and manage websites. liveBooks has raised the bar for excellence in the features that viewers look for—fast loading, easy navigation, and large images. liveBooks allows you to upload and edit your images as you need to, which is essential for maintaining a successful website.

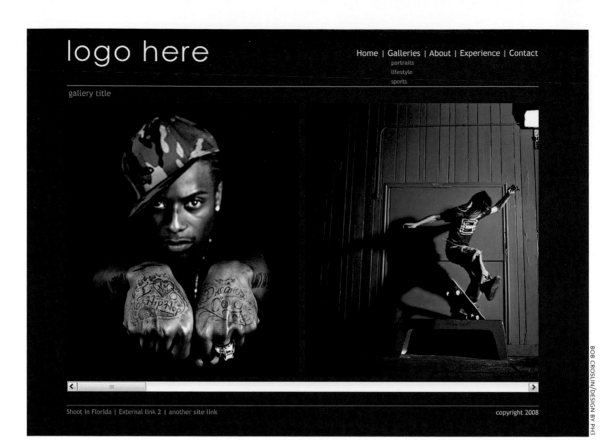

pH3 offers custom websites. We like the scroll bar element of this site. This feature is great for fashion photography; it allows viewers to look at your work as a story, which in the fashion world is crucial for getting assignments.

Brand Envy offers custom websites that allow you the flexibility to create the design you want in your branding of your work.

>>

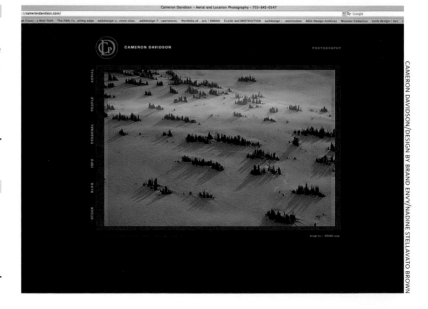

› *Templates*

Using a template site allows you to get your site up within a week or two. Template sites also usually provide very easy navigation. It's also great to have another feature they typically offer—"back-end access," meaning easy updating of images and other content.

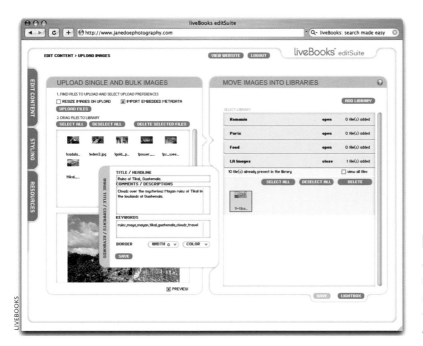

Always make sure you can edit your website. The liveBooks edit suite lets you drag and drop images from your libraries to the portfolio section of your site.

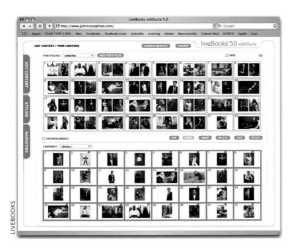

There are many template companies out there for you to research. If you're diligent you'll find the one with the best options for you. The companies whose templates we like best are liveBooks (www.livebooks.com) and Neon Sky (www.neonsky.com). There are also less expensive template sites—for example, www.bludomain.com, www.clickbooq.com, and www.aportfolio.com.

Here are a few basic rules of thumb for finding the right website template:

>> Does it have an easy updating system/program (also called the "back end" of the site)?
>> Does it allow your images to be displayed large? You want to take advantage of the "real estate" of the screen.
>> Is the navigation easy to understand? Is there a constant toolbar for easy navigation?

Lost Luggage has changed the way portfolios are made. They use metal hinges rather than the typical cloth hinges. They also stand out in the industry for their use of other innovative materials—felt, acrylic, carbon fiber, and others.

LOST LUGGAGE

Portfolios

Despite the growing importance of websites, clients are still calling in books, which are used especially in client meetings, when final decisions are being made, so be sure to always have a book ready.

Make sure your portfolio is put together properly and attactively. It should be well designed, but the design should not be overdone and take attention away from your images. And remember that your book is usually called in after a client sees your website. Nothing is more frustrating to an art buyer than to call in a book that looks nothing like the artist's website.

A few rules of thumb for a viable portfolio:

>> It should be viewer-friendly—nice on the eye and easy on the arms and hands, not too heavy (no more than 5 pounds) and not too big (11" x 14" is perfect). If you must stray from these guidelines, go only a bit smaller or larger. If your portfolio is 16" x 20" closed, it is 32"

LOST LUGGAGE

This Lost Luggage carrying case protects your portfolio during shipping. Be sure your book fits into a FedEx box or a self-shipping Tenba case.

Eriko Yahiro creates beautiful, hand-made, custom portfolios using traditional bookbinding methods and striking fabrics for an amazing presentation vehicle.

YAHIRO BOOK ARTS

YAHIRO BOOK ARTS

wide when opened, a size that takes up a lot of desk space, which is limited at most agencies and design firms.

>> Whatever size you choose, make sure it fits into a shipping case or standard carrier box (Federal Express or UPS).

>> Last but not least, try to make your portfolio stand out from the crowd. Would you be inspired to grab the 11" x 14" black faux leather portfolio or the red suede one or even the cool black carbon-fiber material portfolio?

HOW MANY IMAGES SHOULD BE IN YOUR PORTFOLIO?

Photographers always ask this question, and the answer is that there is no set number of images per portfolio. Each portfolio is different. Your images should dictate what you show, how many images you include in your portfolio, and the portfolio's size. If we are pressed for a number, we usually say that a typical portfolio might include somewhere between 40 and 80 photos.

The images in the portfolio should flow, and overall the book should increase the viewer's interest in seeing what comes next. Many photographers think that the way to make a good impression is to show their best work up front. But this may set the standard for the book too high, and the rest of the book can feel "diluted" or anticlimactic.

We recommend that you spread your "hero" shots throughout your book so viewers see your strongest work throughout, leaving them with an overall experience of strong photography. Many creative people review a portfolio "Japanese style"—starting at the back and moving through to the beginning—so be sure that your book is strong from back to front as well as from front to back.

printed portfolio

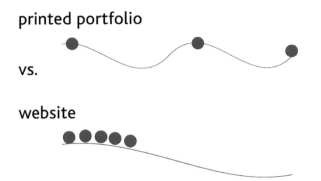

vs.

website

Your portfolio needs to have "hero" (or "killer") images at the front, middle, and end as you never know how someone will review your portfolio. On the other hand, your website should have the "hero" shots up front—on your site you have about five images to make an impression.

A great way to see if your images are flowing well is to put them into a template (in iPhoto on a Mac only; with a PC, use Powerpoint). iPhoto will crop your images, but it allows you to see them together, as if laid out in a portfolio. You can "flip" through the book with the arrows or print a PDF in Adobe and review it on paper.

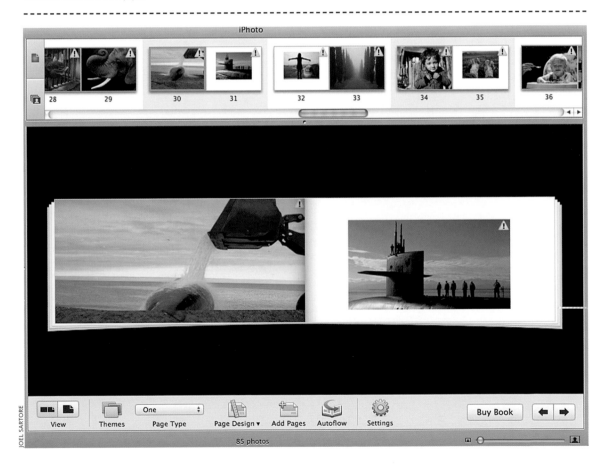

How often do you call in books for jobs?

I don't call in portfolios until the photographer's website links have run through the art director. I call in the books when they are the final selects. I call in books 100 percent of the time for new projects and only for jobs that are being produced.

—ANGELA LEWIS REID, SENIOR ART BUYER,
DRAFT FCB GROUP, NEW YORK

I work 100 percent from websites, unless a photographer is local and doesn't mind stopping by. I don't like to take the responsibility for handling portfolios (they cost a pretty penny), and my clients can't afford the hefty shipping costs. I'd much rather that money go into the actual shoot. Lord knows, my budgets are small enough.

—TIFFANY CORREA, ART BUYER,
PUSH, ORLANDO

The majority of the art directors at Bravo won't shoot with a photographer unless they see the book.

—JACKIE CONTEE, FREELANCE ART BUYER;
FORMERLY ART BUYING MANAGER
FOR BRAVO, NEW YORK

We are still calling in books, but we are seeing a trend of many projects coming from websites.

—DOUG TRUPPE, INTERNATIONAL AGENT,
NEW YORK

PORTFOLIO OPTIONS

Earlier in this chapter we talked about budgeting your time and money. Once you decide how much of each you have available for your portfolio, you'll need to decide what type to create.

Don't be discouraged if you don't have as much budgeted time or money as you'd like. Start out with what you can afford, and perhaps in six months to a year you'll have saved up enough to create the portfolio of your dreams.

› *Customized Portfolio with a Personal Logo*
Visit a store that sells portfolios to see the product up close. Do thorough research, comparing the overall product and its components: size, material, design, styling options, etc. For the cover, you can select a material and a binding in various fabrics, with your name and/or logo embossed.

KAT DALAGER

Once art buyers have been on the job for a while, all portfolios start to look alike. How can you make yours stand out from the group?

- -

If you can go to stores that offer custom portfolios—or to PhotoExpo (www.photoplusexpo.com), where vendors show samples of their products—look at the samples closely. Most off-the-shelf portfolios are returnable, which gives you the opportunity to look at a book closely and return it if needed.

A custom portfolio maker should be able to send you samples of the materials you are considering. Some material samples will be for review only and will need to be returned to the portfolio maker.

A portfolio cover can cost between $100 and $500. Then factor in the costs of any embossing ($100 and up), a shipping case ($100 and up), and paper and ink ($100 and up; see more on papers on pages 51–54).

Or you can do your research and buy online. Some of the best customized portfolio companies are:

>> Lost-Luggage. www.lost-luggage.com

>> The House of Portfolios. www.houseofportfolios.com

>> Brewer-Cantelmo. www.brewer-cantelmo.com

>> Eriko Yahiro. e-mail eriko@yahirobookarts.com

>> Advertisers Display Binders. www.adbportfolios.com

> **WHAT'S IN A NAME?**

If your portfolio has a separate shipping case, make sure it has your name on it. If you can't afford to have your name embroidered or embossed on the case itself, then have one of your business cards laminated and create a luggage tag out of it.

>> Mullenberg Designs. www.mullenbergdesigns.com

>> Roswell Bookbinding. www.roswellbookbinding.com

> Off-the-Shelf Portfolios

A quick and inexpensive option is to buy a portfolio right off the shelf. You won't get custom features, such as embossing or etching of your name. But you will get an affordable, professional-looking book.

Off-the-shelf portfolios come in a relatively limited number of materials and sizes. Most are common sizes like 8" x 10", 9" x 12", and 11" x 14"; they can be horizontal or vertical. Many come with professional carrying and shipping cases. Materials range from acrylic and plastic to fake leather. With most off-the-shelf portfolios, the retailer does not emboss your logo on the cover; you can have a third party emboss, etch, or silk-screen it, but depending on the material, this may be difficult to do.

There's an interesting option that addresses the issue of your name on the cover: Portfolios from Case Envy (a line from Lost Luggage) have clear covers that allow your name to be seen before the viewer opens the book, but without the need to pay for an embossed cover.

Even if you are on a tight budget, avoid selecting a book that looks like a "student portfolio"—a black plastic zipper portfolio with multiple rings and shiny plastic pages, a book that you carry like a briefcase, or one with pages you can remove. Fair or not, portfolios like this will tend to "cheapen" your work in the eyes of the viewer.

These are good places to find off-the-shelf portfolios:

>> Rex Art (www.rexart.com). On this site you'll find off-the-shelf portfolios and presentation cases by Case Envy as well as Tenba cases designed for shipping.

>> Paper Haus (www.paperhaus.com). Again, check out the Case Envy products; Paper Haus offers the "Ice Nine" from Lost Luggage—a professional and affordable portfolio.

>> Kate's Paperie (www.katespaperie.com). This New York City retailer offers screw-post portfolios by smaller companies, like Molly West, as well as other hand-bound portfolios. Kate's also offers many materials you can use if you're making your own portfolio.

>> Molly West (www.mollywest.com). Hand-bound books.

> *Making Your Own Portfolio*

We have seen many handmade books that are fantastic. If you want to make your own portfolio, first decide what you like and dislike about the different presentations you've seen. Consider everything from the overall type of book you would like to have represent you and the paper you'll use to the types of sleeves, if any, and the hinges that will keep the book together.

For those of you who want to investigate making your own portfolio in greater detail, these are four excellent books:

>> *Books, Boxes and Portfolios,* by Franz Zeier. McGraw-Hill, 1990.

>> *Hand-made Books,* by Rob Shepherd. Search Press, 1995.

Make sure you allow for gutters if your images will "gutter jump" from one page to a facing page. This is a final PDF version, created in iDesign, of how the image will look when printed. When bound in the finished book, the two parts of the image will bleed nicely into one another.

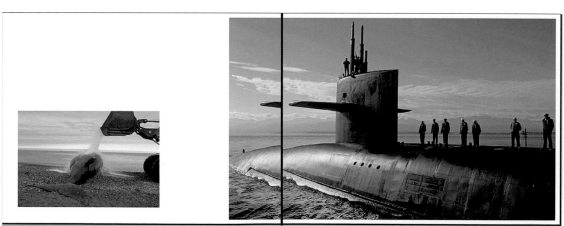

JOEL SARTORE/DESIGN BY BRAND ENVY/NADINE STELLAVATO BROWN

>> *The Essential Guide to Making Hand-made Books,* by Gabrielle Fox. North Light Books, 2000.

>> *Pages: Innovative Book Making Techniques,* by Linda Fry Kenzle. Krause Publications, 1998.

Talas (www.talasonline.com) sells all the materials you need to make a book yourself, from chipboard and screw posts to fabrics. The company is also a professional printer; it creates perfect-bound, printed portfolios that look like coffee-table art books, which is another option for people who don't want or can't afford a customized book or one off the shelf.

Following are other companies that provide high-quality printing of perfect-bound books that you can use as your portfolio:

>> www.paperchase.net offers high-quality printing for portfolios (and mailers). They can produce "coffee table" books for customers who don't need a large press run. This is high-end printing, and the books are finished with hand-stitched seams.

>> www.asukabook.com and www.blurb.com provide high-quality printing at a reasonable price.

>> iPhoto is an application for printing books, calendars, and cards that is built in on Mac computers. It can also be purchased with iLife, an

After you review your work in iPhoto or PowerPoint, you can have a designer (in this case it was Nadine Stellavato Brown) design your portfolio in InDesign, a program by Adobe. It will show what the viewer will actually see.

Asuka makes great leave-behind or small-run portfolios.

Apple program. The print quality isn't as good as what Asuka and PaperChase provide, but iPhoto is very affordable for fun and quick printing.

>> Aperture is a more expensive and higher-end version of iPhoto, but it is a more versatile Mac program.

> *Sealing the Inside of the Cover of Your Handmade Book*

When a portfolio cover is bound in fabric, it must be "sealed" on the inside of the cover with a "blotter panel" that conceals the seams. You can have fun with some great specialty papers that will make those panels stand out. Here are some good suppliers of specialty papers:

>> www.artsuppliesonline.com

>> www.paperaccess.com

>> www.handmadepapers.biz

>> www.custompaper.com

>> www.thepapercatalog.com

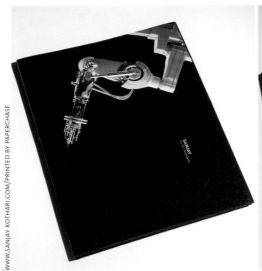

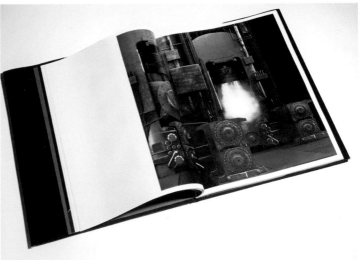

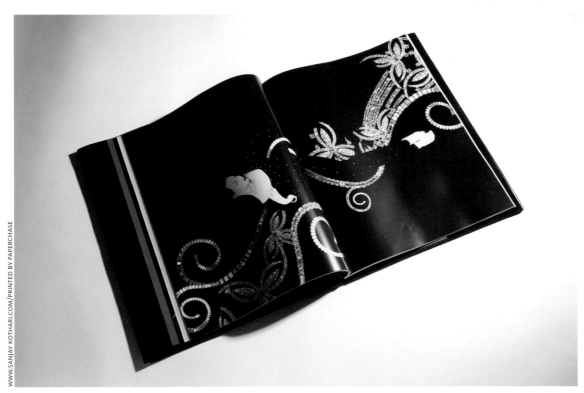

A printed piece like this from PaperChase has the "Wow!" factor. You can have them print one or several books that really impress the viewer.

>> www.ztapdesigns.com

>> www.hollanders.com

>> www.paperhead.com

> *Binding*

Following are the most common types of binding for portfolios:

>> **Screw-post.** The metal posts are in two parts—one male, one female; once hole-punched printed images or sleeves are in place, you screw the posts tight.

>> **European-bound.** Bound plastic pages stitched or glued so you cannot add or remove pages. Use in consumer photo albums or lower-end portfolios.

>> **Self-published.** A perfect-bound book (meaning it's stitched and/or glued) that has the look and feel of a published book.

>> **Handmade.** Images that you print and then place in a book that is put together with any number of types of materials to form a portfolio-like presentation.

>> **Loose prints.** Images that are printed on paper and put into a box to be viewed individually. Once you send this type of presentation, you lose control of the order in which viewers may see your work; since the prints are not bound, they usually get shuffled around.

With a screw-post portfolio, one of our favorite types, it's easy to add and remove pages based on what you want to include. This design creates a nice gutter that allows your images to turn over comfortably.

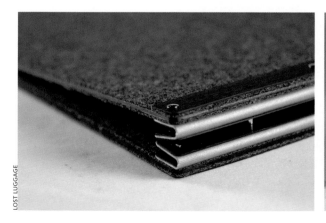

LOST LUGGAGE

LOST LUGGAGE

MOAB BY LEGION PAPER AND LOST LUGGAGE

Moab paper has teamed up with Lost Luggage to create two-sided, pre-scored paper that lets you avoid a lot of the hassle of adding hinges yourself. The paper has pre-scored hinges and a leader stripe that fits into your portfolio for a professional presentation. The paper's triple scoring gives it flexibility for viewing.

MOAB BY LEGION PAPER AND LOST LUGGAGE

It's best to buy a screw-post portfolio (custom or off-the-shelf), which allows you to edit the pages and expand if needed. A screw-post portfolio can be used with acetate sleeves or printed pages with hinges or pre-scored. This type of binding can be hard to find or create if you are doing it on your own, but it is worth it for a really professional presentation.

❯ *Paper and Printing*

Papers absorb ink and reflect light differently. It's important to choose the right paper to show your images in the best light, literally and figuratively.

When choosing a paper for the photographic prints in your portfolio, make sure to always test for consistency and compatibility with your images and your printer. While papers and weights can vary considerably, a 90-pound inkjet paper generally looks good and works well in a portfolio—it accepts color well and is sturdy enough to remain intact when hole-punched. And 90-pound pages turn more easily than those of a heavier weight; many viewers flip through a portfolio, so you don't want the pages to be too thick.

Which finish to use is a matter of personal taste, but matte finishes usually look better under all conditions. A glossy finish can create a glare on your images that interferes with the viewing process, like sunlight coming into the room and falling on the TV screen. Today a glossy finish is viewed as amateurish, and most portfolios are not printed on glossy paper. As a general rule of thumb, matte paper looks more elegant and shows your work better.

Good sources for papers that are often used in portfolios include Moab (www.moabpaper.com; also available through www.lost-luggage.com under products/accessories, www.epson.com, and www.lumijet.com).

If you don't want to or cannot print your own work, Pushdot Studio (www.pushdotstudio.com) is the answer. They can handle all of your printing needs at a reasonable cost.

❯ Sleeves vs. Double-Sided Paper

There are benefits to using acetate (thinner) or plastic (thicker) sleeves to hold your photographs within your portfolio. They keep dirty fingers from smudging your photographs; they make it easy to edit—add and remove images—quickly; and since they use two separate prints, each made on a single side of a piece of paper and inserted back to back into the sleeve, they allow for easier printing when you want to make a change.

However, acetate or plastic sleeves look kind of dated, and they add the potential for glare. Another downside is that they have the effect of taking an image down (that is, darkening the exposure) by half a stop or more.

If you use sleeves, always use the same brand and style. Nothing makes a book look more amateurish than mismatched sleeves. Also, acetate or plastic sleeves will eventually get scratched, so you must replace them when that happens. When you order sleeves, always order a lot of extras for replacing sleeves when they become worn.

If you present your images in sleeves, be sure to label the back of the photographs as well. Many art directors pull out single images and later deliver them loose back to the art buyer, and unless the images carry the photographer's name the buyer won't know which portfolio the image belongs to.

Printing on double-sided paper allows you to avoid acetate sleeves and thus get a cleaner and more "organic" look, but printing photos in this

A plastic or acetate sheet protects your images but will scratch and shows reflections. You have to decide if the tradeoff (the reflection) is worth protecting your work. Another downside: Some sleeves can lower your exposure half a stop or more.

- -

way takes careful advance planning; you'll need to have the portfolio's pagination worked out in order to do the printing correctly. Also, changes will be cumbersome, as changing one photo really involves two images; when you change one image you also have to reprint the one on the back.

What is our recommendation? Double-sided printed pages make your images stand out and show them to their best advantage, without any glare from sleeves. Most people who will look at your work would rather see the prints directly, not through acetate or plastic. It's true that editing is a pain, what with the double-sided printing that's involved. But what you get is a more pure and more sophisticated product.

Test types of paper to find those that work best with your images. Some papers "drink" ink and can make your images bland. Most people have good luck with Hahnemühle's (www.hahnemuhle.com) double-sided Photo Rag. You can find pre-scored double-sided printable paper to fit into a Lost Luggage portfolio from Moab at www.lost-luggage.com (look under products/accessories).

› DON'T SWEAT THE WEAR AND TEAR

Sleeves get scratched and paper gets frayed—these and other small damages are an unavoidable aspect of showing your work. We urge you to take this in stride. Consider it part of the price you pay to get assignments. What it costs to replace the sleeves or the prints is a lot less than the money you can make on one assignment.

› *Hinges*

If you want to hinge your favorite paper into your portfolio so the pages lie flat, there are two good sources:

›› www.lost-luggage.com. Look under products/accessories/hinges.
›› www.lightimpressionsdirect.com. Look under tapes & adhesives/ tapes/archival grade tapes/tyvek tape.

HOW MANY PORTFOLIOS SHOULD YOU HAVE ON HAND?

We recommend that you have a minimum of four books, but if you're financially strapped you should be able to get by with two. It used to be more, but in today's electronic world, many projects are assigned without the need for a conventional portfolio. Yet you must have some books on hand for those who require a portfolio for client presentations and for one-on-one meetings.

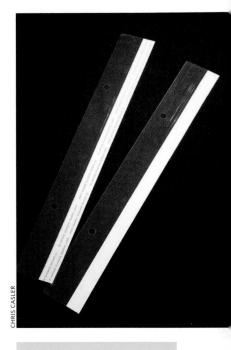

CHRIS CASLER

The hinge shown here is from Lost Luggage.

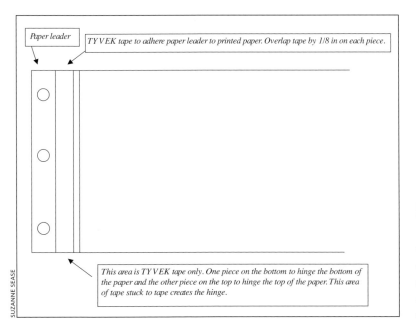

Paper leader

TYVEK tape to adhere paper leader to printed paper. Overlap tape by 1/8 in on each piece.

This area is TYVEK tape only. One piece on the bottom to hinge the bottom of the paper and the other piece on the top to hinge the top of the paper. This area of tape stuck to tape creates the hinge.

SUZANNE SEASE

If the paper that works best with your images is not pre-scored, you will need to add your own hinges. Tyvek tape (available through Light Impressions) is both adhesive and durable.

August Bradley used PaperChase both to create a stunning promotional mini-port-folio mailer and to make a smaller, leave-behind portfolio that caught the attention of people who would eventually hire him. It said to the market, "This guy means business."

LEAVE-BEHIND PORTFOLIOS

These are printed booklets that represent a smaller sampling from your portfolio. Usually about 6" x 9" or somewhat larger, these mini-books are great for showing off an alternative style that you can offer or a per-sonal project that may not fit into your traditional portfolio.

See "Making Your Own Portfolio" (pages 46–51) for a list of companies that can produce both larger portfolios and smaller, more specialized leave-behind books.

Using a Designer

A designer can add a tremendous amount of value to your presentation of yourself as a professional photographer. You can hire a designer to do anything from a logo and type treatment (the font you use for your brand and materials; see much more about this in the following chap-ter) to a full brand design covering all your marketing materials—logo and type treatment, business card and letterhead, website and portfo-lio design, printed promotional materials, etc.

What do you think of leave-behind mini-books?

I love leave-behind mini-portfolios.

—KAT DALAGER, SENIOR ART PRODUCER,
CAMPBELL-MITHUN, MINNEAPOLIS

I don't have much room for a lot of books, but I will keep a mini-book if there is something great about the work.

—JESSICA HOFFMAN, SENIOR INTEGRATED ART PRODUCER,
CRISPIN PORTER + BOGUSKY, BOULDER

FINDING A DESIGNER

If the design firms in your area are too expensive, shop around. The good news is that our current technology allows you to hire a designer from anywhere. Consider freelance designers, art directors from ad

before after

AMANDA: SAY IT LOUD

AMANDA: NICK ONKEN; SUZANNE: NADINE STELLAVATO BROWN

All design professionals—including photographic consultants—need to take the time to work with a designer. Evaluate your logo every few years to see if it needs to be updated.

- -

Fred Greaves's logo and mailers looked dated. The type treatment and colors needed a facelift.

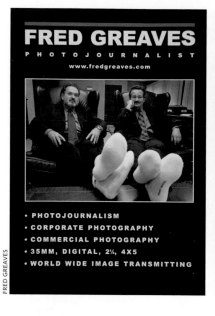

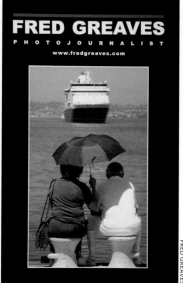

Fred worked with Nadine Stellavato Brown to create a fresh logo with traditional type but presented with fresh colors and style. Fred's first new mailer was a several-page booklet that announced his new look and his new website. The front, back, and interior of the new mailer are shown to the right, and the opening page of the website is on the opposite page.

>>

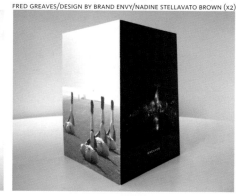

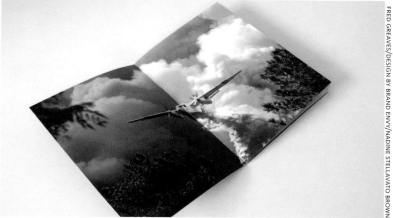

agencies who may want to do some work on the side, and design students. Ask your friends and colleagues if they know any designers.

A word of caution to those who have a family member or friend who is a designer: Working with family or friends can often mean that you are not able to be 100 percent honest in your reactions to the work they do for you. And if they are doing the design work for free or at a deep discount, their other projects may take precedence and you may have difficulty getting the work done in a timely way.

Universities and art schools can be terrific sources of talented, young graphic artists willing to do design work for low or no cost in order to get printed work for their portfolios.

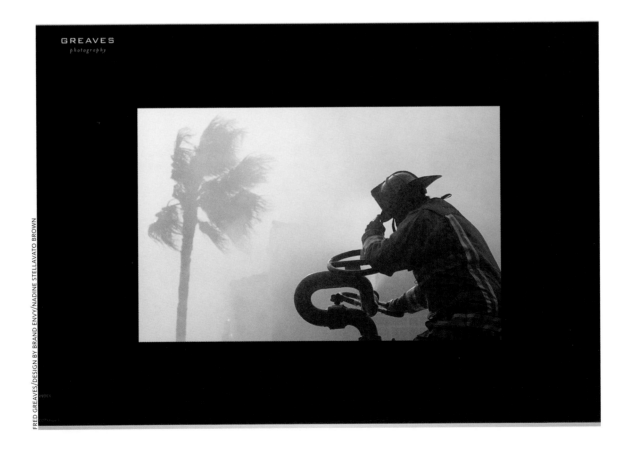

FRED GREAVES/DESIGN BY BRAND ENVY/NADINE STELLAVATO BROWN

WORKING WITH A CUSTOM WEB OR
BRANDING DESIGNER

Try the following exercise as a first step in deciding what you might talk about in an initial conversation with a designer. In her book *Successful Self-Promotion for Photographers,* Elyse Weissberg recommended coming up with five key words about yourself—your identity and your work—and letting those words help you decide on the style you want to present to the world.

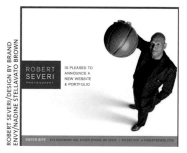

On a small scale, if you were to choose "honest," "creative," "hip," "smart," and "funny," this **Cracked font** may fit four out of the five key words. But if it doesn't fit all five, then you know it's not the right font. The next step is to ask everyone you know which one to use. A way to avoid analysis paralysis—or what Amanda calls "analyzation paralyzation"—this exercise can help not only with type treatments but also with website, portfolio, and marketing design.

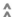

No matter whether Robert Severi shows his logo and his work horizontally or vertically, his branding is consistent.

- -

Bob worked with Nadine Stellavato Brown to create a clean-looking website that attracts viewers. It is branded with elements that appear on all of his marketing materials.

- -

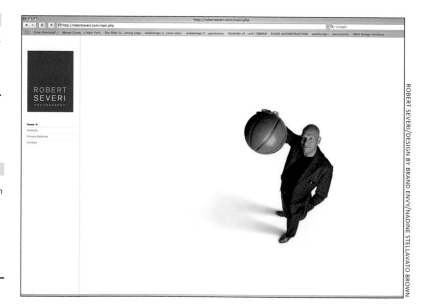

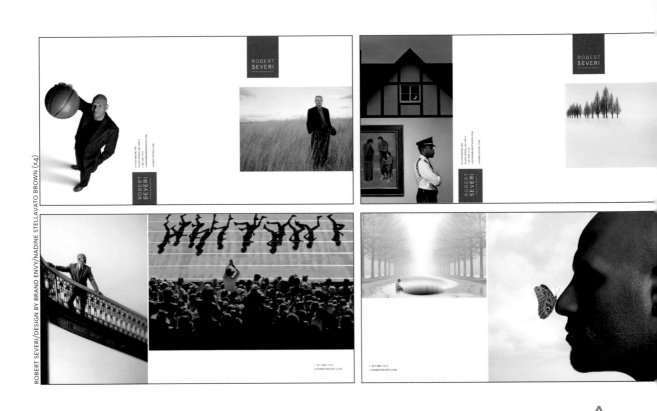

ROBERT SEVERI/DESIGN BY BRAND ENVY/NADINE STELLAVATO BROWN (X4)

AMANDA SOSA STONE

joe blow

JOE BLOW

joe blow

JOE BLOW

joe blow

Working with Nadine Stellavato Brown to create a branded mailer campaign, Bob Severi sent Modern Postcard's tri-fold mailers to potential clients.

- -

If you can't afford or don't want to work with a designer, become one yourself. Type your name in a Word document and try several typefaces (fonts) to see which one looks best with your name and is a type style you would want to represent you. Save the treatment as a jpeg so that all computers can view it even if they don't have that font.

- -

<<

When working with a designer, always outline your expectations up front. We recommend that you ask for three totally different designs in order to see a variety of options.

Once you select a basic design approach (which may consist of elements from each of those three very different designs), be sure to agree with the designer that he or she will provide three revisions, if necessary. Some design is good from the start and needs little or even no revision. You will know when a good design has hit its mark when your gut tells you or when it meets the five-adjective exercise noted above.

Different designers may have varying ways of working, but always ask up front what you are agreeing to pay for. Most designers will agree to three designs and three revisions in return for the price you agree on. Revisions after the third revision may be at an additional cost; again, ask about this up front.

Working with a designer who understands photographers and the types of designs they require is crucial to creating a great logo for your branded image. Your logo is a reflection of you and your business. Even if you already have a logo, you need to update and evaluate it every three to five years.

Type treatments or icons with consistent branding become visuals rather than words. Take the word "Nike." You automatically see the type treatment in your head. When you see the word "Nike," you no longer just read it—you see the visual, the swoosh. It's the same with Apple Computers—you see the apple. When you think of Target department stores, a bull's-eye or target comes to mind. Think about Herb Ritts or Richard Avedon—you might actually be able to see their type treatments in your head. This is what you want people to do with your name—see it and associate it with your particular style and imagery.

DESIGNER TAMERA HANEY'S RECOMMENDATIONS

Your identity as a photographer needs to stand out from the crowd, to be memorable and unique. This idea calls to mind the power of the first impression. In a business saturated with talent, standing out is crucial to getting work.

When Scott Smith worked with designer Tamera Haney, owner and designer of Bliss Design Boutique, she gave him several choices and asked him to select the one he felt worked best for him. Make sure your designer gives you plenty of options. Discuss this up front so it is included in the estimate.

Scott Smith's final selection.

When I work with a photographer, I make the following requests:

›› Give me five to ten adjectives that describe you in a creative nutshell—your work, your personality, and your style.

›› Give me a list of colors and color combinations you are attracted to. I am usually pretty good at this, but if you feel that a certain color combination—say, a neutral tone paired with a rich red—works well with your images, then let me know. Think about iPod and its memorable campaign with primary colors and black. Now Apple is building on that original idea and evolving into more colors, but initially it

Tamera Haney gave Melissa Castro a choice of several styles that she thought represented her work. This was Melissa's final selection. She is an architectural photographer, so the graphic elements fit well as part of her logo design.

was the color, the graphics, and the brand identity that helped ignite their campaign. Colors are more important than most people think. They evoke emotions.

›› Send me examples—jpegs, PDFs, links, names, places—of anything you find inspiring: artwork or an ad or a CD cover or a website that has that certain something you connect with. This may take you a while, but be on the lookout as you move about your day. And tell me why it grabbed you, what it was about it that moved you. This will help me to get an idea of what inspires you.

Your brand or identity needs to complement your photography without overpowering it. It needs to accentuate it. You need to keep it clean, modern, and timeless.

TIPS FROM DESIGNER
NADINE STELLAVATO BROWN

Nadine, owner and head designer of Brand Envy, a division of Lost Luggage, says, "Our credo at Brand Envy is: The cumulative effect of a consistent brand is the most important thing you can do to build your business."

In other words, do not create ten promos that all look different.

>> Never hire a friend or family member to do your design, primarily because you cannot be truly objective and tell them if you don't like something for fear of hurting their feelings. Also, you may want to

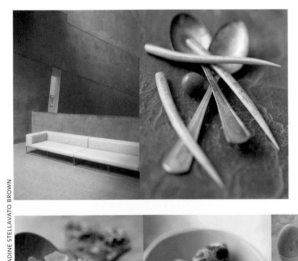

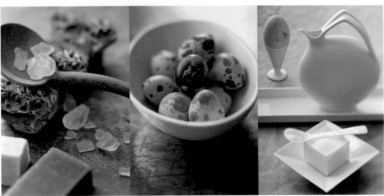

TUCKER & HOSSLER/DESIGN BY BRAND ENVY/NADINE STELLAVATO BROWN

Tucker & Hossler worked in many different styles and needed to send out mailers that captured them all. When working with a consultant and designer (Nadine Stellavato Brown) to create mailers, they worked with colors to create unified looks.

douglas sonders photography
NY | DC | LA

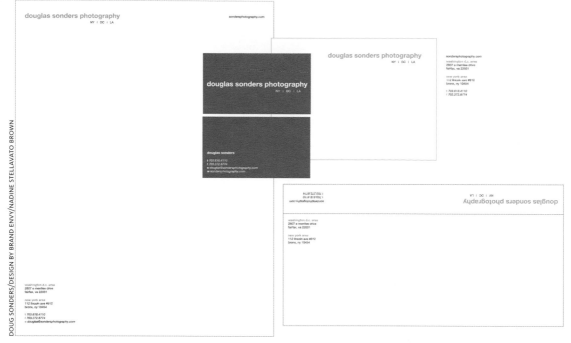

DOUGLAS SONDERS PHOTOGRAPHY

Make sure your designer shows you samples of how your work will look in all of your stationery elements. The three samples shown here, by Nadine Stellavato Brown, are the designs that were first presented to photographer Doug Sonders. In the end Doug did not chose one of these samples. Even though others may like a certain look, you have to make sure the branding treatment is right for you.

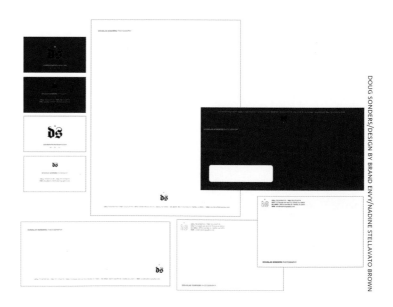

rush to make sure you are not a burden, which could compromise the final design. Last but not least, if your job is either discounted or free, you will not see the value in the brand since you have not had to pay real money to make it happen.

>> Your design firm or designer must be current and must understand the ad market. Why? You are creating a brand to sell. Outdated design style will not sell. Firms understand how to create promos and marketing materials that are outside the box—or, in this case, the "postcard." You are creative and so is your target audience. Do not

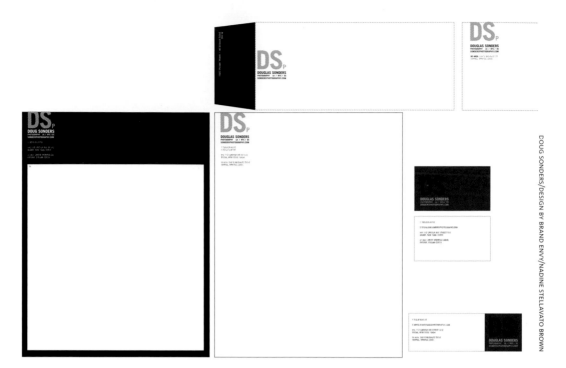

Here is the logo branding treatment Doug Sonders chose. It felt right for him and his business.

insult them with promos that ignore this simple fact. Find a designer who can show you a lot of design examples, so you have a clear understanding of his or her design style.

›› Find a designer who is willing to work with a photographic consultant. In today's market, it takes a village to launch a photographer. You need the best people to help you get noticed by your desired audience, and a team is far better than an individual going it alone. Working with a team also allows you to see the designer's ego, which helps to determine if your career is the priority or if it is their portfolio. (It should be both.) Good design work gets you noticed, and a designer with an openness to work with your consultant marries the right design with the right image. Keep in mind that this partnership works both ways. Be sure to work with a consultant who is open to an outside designer and who recognizes good design.

›› To begin, give your designer examples of your current design and the marketing items you currently use, as well as examples of designs

you like—from printed restaurant cards or detailed explanations of your personal design style to examples of your personal furniture (do you like Eames or classical Louis XIV style?). Designers need to have a launching point. A brand is effectively a new skin, and you should feel comfortable with it. Not as comfortable as in your favorite flip-flops, but you must be as proud of your new brand as you are of a nice piece of furniture.

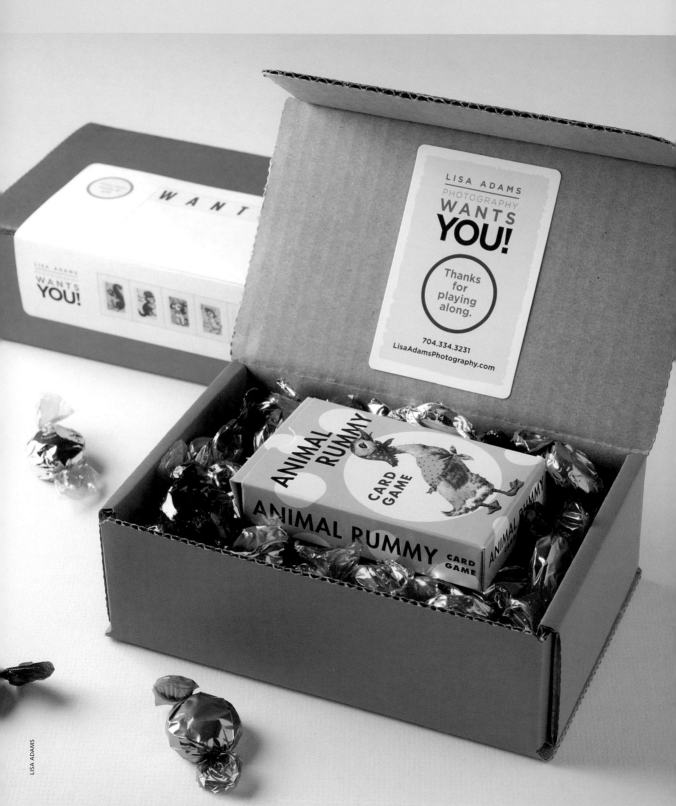

03

MARKETING

AFTER YOU SEND AN E-PROMO, AN ART DIRECTOR CLICKS ON YOUR WEBSITE. YOU FOLLOW UP BY PHONE, SAYING, "I KNOW YOU WENT TO MY WEBSITE. CALL ME BACK SO I KNOW WHAT PROJECT YOU WANT ME FOR."

WORST-CASE SCENARIO: YOU SENT OUT A MAILER AND HAVE NOT SEEN INCREASED HITS TO YOUR WEBSITE OR MORE REQUESTS FOR YOUR PORTFOLIO. WHAT'S GOING ON?

WORST-CASE SCENARIO: YOU ENTER PHOTO CONTESTS LIKE CA, BUT NEVER GET IN.

Assuming anything from someone visiting your website is a big mistake, and the chances of your mailer arriving at the very time someone is looking for your style would be amazing. In most cases, when an art director likes your mailer, she puts it in a special folder that might be labeled "One day when I have the perfect project, I want to use this person."

Be realistic about your work and what will get you into contests. The judges are creative people who are looking at commercial images for *Communication Arts, Lucie, IPA, PDN, Archive,* and *Graphis.* Fine art can be appropriate for some of the competitions, but what does your entry offer? Submit work that would inspire creative people who give out commercial assignments.

The Challenges and Benefits of Marketing

Remember that marketing is a numbers game, and you are working toward a goal of educating the market. This may be a cliché, but if you are patient and consistent, your efforts will eventually pay off.

How do you find talent?

It depends on the project. Do I need an advertising person, or maybe a person who shoots snowboarders for editorial, or an e-commerce Web photographer? Basic requirements like these drive my efforts. I will go to magazines and websites. I've even recently found a photographer of buildings through a website for the contractor on a building project. Most commercial ad photographers can be found in sources like CA, Archive, *and* Photo District News *online. I also view the reps' websites.*

—JESSICA HOFFMAN, SENIOR INTEGRATED ART PRODUCER,
CRISPIN PORTER + BOGUSKY, BOULDER

I use a combination of promo cards, online sourcebooks, individual websites, agent websites, award show books, other publications, and my own memory.

—KAT DALAGER, SENIOR ART PRODUCER,
CAMPBELL-MITHUN, MINNEAPOLIS

If there are no signs of work after a year of consistent marketing, sit down and review what you have done and what you can improve. Doing this with a consultant or marketing manager can be helpful, as sometimes it's hard to see the forest for the trees.

Here is one of the most important pieces of advice we can give: You must make sure all of your materials are consistent. Carefully consider everything you present—from your website, portfolio, e-promos, and mailers to your correspondence mailers.

In this chapter we'll lay out the options for your marketing campaign. Among other issues, we'll discuss mass marketing versus specialized marketing. You'll need to decide whether to send special mailers to a small group or an e-mail blast or maybe a postcard mailing to many— kind of like throwing spaghetti against the wall to see if it sticks. The bottom line is that if you market to only a few people, you are limiting yourself. You really need to do both.

The chapter's final section is a marketing template that you can use to get started.

The Marketing Spectrum

To whom should you market? Open your eyes and look around. You will see what is being advertised and who is doing the advertising. Look at the magazine section in a bookstore. Check out local publications and survey in-store displays. Take a moment to think about what those images tell you. As photographers, we are in sales. We create images that sell a client's product. You need to decide how your work can be utilized.

PHOTOGRAPHER: ALEX MCKNIGHT/CONCEPT: TINA DELGADO/ART DIRECTOR: PAUL MAHAN/STYLIST: SUSAN SAWRENCE

You are targeting creative people, so be creative. For his dream client list, Alex McKnight created an attention-getting mailer. He put apples in a box, along with a mailer featuring an image of a man with an apple on his head, under the headline "I shoot people." A great mailer like this gets the viewer's attention.

DREAM CLIENTS

Dream clients are up to 25 special people you would love to work with. Send them special campaigns of printed material four times a year, using a consistent campaign theme. For example, send large prints from a series, one each quarter. At the end of the year, an art director or buyer will have an entire series from an artist that they can hang up. Be sure to print your website address on the back. Everything is a marketing tool in the end.

The best places to find out who should be on your dream client list are award show/contest annuals like the *Communication Arts* photography competition, design or advertising annuals, the *Photo District News* photography awards, the One Show, *Graphis*, and *Archive*. Each of these annuals lists art directors' names and the agencies they work for.

Periodically double-check the names on your list of dream clients. Have a database company like Agency Access (www.agencyaccess.com) research whether the art director still works at the agency. Often, after an art director wins a prestigious award he or she is lured away to a larger or more creative company.

Leslie Jean Bart was hired by Circuit City to do a photograph for a holiday CD; he then used that image as a marketing piece for his own promotions. A product with your image on it has an impact. When it speaks the language of your dream clients, use it as part of your promotion efforts.

MASS MARKETING

In this category you should have everyone who has money who will hire you, plus your existing market and contacts. Your means of attack? Both printed and e-promotion materials.

Again: The more people you market to, the more exposure you will get. Your materials will have an impact on only about 1 percent of your mass mailing contacts. Do the math and make sure that your 1 percent

success rate is enough. If you make 100 contacts, one person will go to your site, but if you make 10,000 contacts, about 100 people will.

PERSON-TO-PERSON

Arrange an in-person meeting with one or two new potential clients every month. Doing this means you will meet between 12 and 24 new people every year.

If you are trying to get an appointment, first ask about the buyer's portfolio policy. Some review portfolios only on certain days, while others allow only drop-offs. Others may require you to bring food, like breakfast, or a nice treat, like cupcakes. (Sounds crazy, but this really happens.)

If you are planning to be part of these in-boxes, be sure to make your promotions stick out from the rest.

- -

ONLINE RESOURCES

Use both free online sources and those of local organizations. To find talent, buyers go to online source books like www.work-book.com and

KAT DALAGER

KAT DALAGER

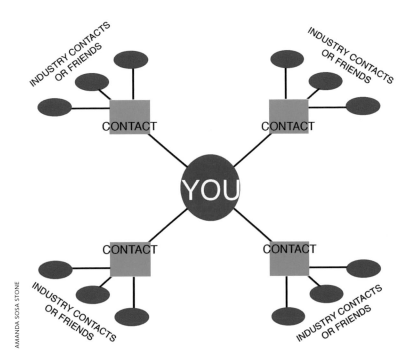

It is very important to have person-to-person meetings, which can be easier to set up if you are from out of town. After these meetings, make sure to maintain contact with the person who gave you his or her time. When you connect with a person, you open the possibility of being in contact with their colleagues in the industry.

www.photoserve.com. (We give a longer list later in the chapter.) If you are a member of a professional photography organization, such as Advertising Photographers of America (APA) or American Society of Media Photographers (ASMP), make sure you are listed in their database. Such databases are designed for clients looking for talent in the city where they will shoot.

EXISTING CLIENTS

Your hope is that an art director will remember you after a shoot, but this can be hard when they are seeing fresh names daily. You know the old saying: Out of sight, out of mind. You need to stay in their consciousness, so here's another old saying: The squeaky wheel gets the grease. If creative people don't hear from you, they may think you have

moved on to other pursuits. Don't let this happen to you. Piggyback on mass marketing and holiday greetings. Send appropriate holiday gifts to the clients you want to keep.

The CD included with this book provides a Contact Database Template. Type onto the digital Excel document the names of your existing clients and those you are targeting for work in the future. (See Appendix B.)

Establishing Two Key Lists

Along with a terrific style, Gregor Halenda has a well-rounded campaign theme. His website, promotion, and printed promo complement one another.

We advise photographers to get started by using a formula that combines mass marketing and specialized marketing. After a year or two, you will know what works for you and what does not. Many of our

GREGOR HALENDA

clients have used this two-pronged formula, and what works for one does not always work for the other.

MASS MARKETING

Create the longest list you can afford, targeting the people you'd like to work for. Send marketing to these contacts with a plan in mind—for example, the type of promotion and how often and how long you will continue sending it—that accommodates your budget. We recommend repeating this pattern every two or three months for a year or two. Then use a consistent list or revised lists for the rest of your career. Marketing is a long-term undertaking.

SPECIALIZED MARKETING

Create a list of people or agencies you would love to work with and put together a very special marketing campaign specifically for them. If

GREGOR HALENDA/COPY ART BY CHRIS CASLER

To complement his website, Gregor's designer came up with a campaign that had a "fade in" effect. The promotion was sent in stages over the course of a month. The image came more into focus with each arriving card. The final mailing was a three-panel card that opened up to show the sharp image. Gregor's images appear regularly in national consumer magazines.

- -

your budget is limited, focus on a small number of people. If you have a healthier budget, you can focus on agencies or companies as a whole. This can be a long-term or a short-term plan.

Most creative people save the best printed mailers they receive—photographers they hope to work with one day—or bookmark favorite websites to refer to later. Meanwhile, it may be months or even years before the right project comes along. We advise you to venture into marketing with no expectations and to keep in mind that your first year of marketing is an educational period. You are making the creative industry aware of your presence.

Be proactive when you begin your marketing campaign. Don't take just one approach and get frustrated when your phone is not ringing or your e-mail queue is not filling up with portfolio requests. You have to try the entire marketing spectrum to find out what works for you.

Personal chemistry also plays a role. One client may be open to you dropping by for a chat, while another photographer may have no luck with the same client.

For a year or two, do the extra work involved in trying a variety of approaches, and find out what really works for you. If something is not working, don't just throw your arms up and surrender. Ask why that something isn't working and change it.

Once you start marketing, plan to keep the ball rolling. Plan to market until you retire—and, even then, market your retirement.

Later in this chapter, you'll find advice about and sources for preparing promotions and other printed materials.

Companies and Who Buys for Them

The four largest categories of companies that photographers market to are advertising agencies, design firms, corporations that do their design work in-house, and magazines and other periodicals.

ADVERTISING AGENCIES

At large agencies, art buyers, art producers, or creative buyers are the decision-makers who call in portfolios for the creative people (the art director or the creative director). The creative people are so busy with projects that they need "art supply" personnel to supply them with photographers to consider. In smaller agencies that don't have business liaisons for the art, it is the art director or creative director who finds the photographer.

An advertising agency is structured with many layers. If an agency has an art buyer, art producer, or creative buyer, that person is usually the gatekeeper of the work the agency will consider. At agencies without a producer or a buyer, the art director should be your target.

- -

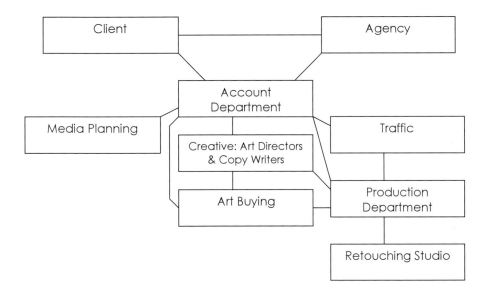

You need to know where you have sent your book and who has seen it. The CD included with this book provides this form, which will help you keep track.

Portfolio Requests

Date	Project/Client	Portfolio Sent	Promo Sent	Returned	Project Awarded	NOTES

DESIGN FIRMS

Design firms do not have set accounts; instead they usually work on projects. Many times they will work on several projects for one client, but their client list varies. The size of a design firm has no bearing on the size of the budget for its projects. At one small shop that works on international projects, for one project alone the fee was $30,000 just for the photographer.

A design firm is structured based on size. In a small shop, the creative director may be the decision-maker, while a larger shop may allow the art director to decide on talent. Even small design firms can do very large projects. To research the work of design firms, use a database such as an Agency Access database (www.agencyac-cess.com), which gives you website addresses for quick reference.

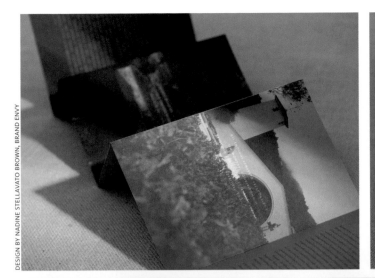

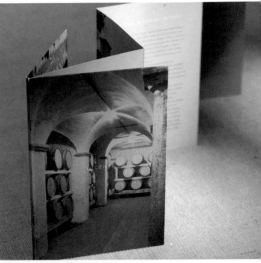

Some of the most creative work comes from design firms. Nadine Stellavato Brown of Brand Envy created this award-winning annual report. An annual report can be a long-term project involving weeks of shooting. It can require world travel and may even win you an award.

IN-HOUSE CORPORATIONS

A great deal of photography work for corporations is done in house. Best Buy, Target, Capital One, and Fruit of the Loom, to name just a few, all do it themselves. And "in-house corporate" is one area that is often overlooked because the rules are not as cut and dried as in the agency and design firm worlds.

Many projects done directly with corporations provide very large fees (think in the $50,000 range). In-house corporations are often more loyal to photographers than are agencies, which often want a new look for each campaign. Companies will often want you to sign a confidentiality form, which means that you promise not to reveal information about the company or its products.

Many corporations have their own in-house marketing departments. Even corporations that use an agency to handle large projects may still do quite a bit in house.

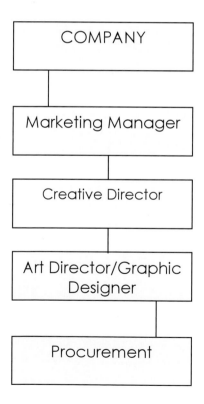

EDITORIAL

In the case of magazines and other periodicals, market only to the art director and the photo editor. These are your top-two "must have" connections. All others on the masthead are responsible for the written content of the magazine, and content editors generally do not choose the photography.

Some magazines have established a new position—design director—that many people recommend promoting to. The person in this position oversees the creation and production of design solutions, manages a team of graphic designers, and directs the magazine's brand. The design director is responsible for the quality and effectiveness of the design team and makes recommendations when assigning talent to project teams. The design director generally reports to and works with the creative director.

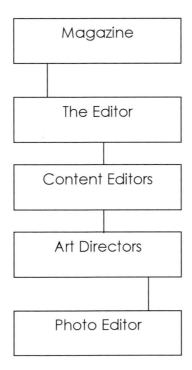

In the magazine world, content editors do not make the decisions about which photographers to hire. The decision-makers for photography are usually the art director and the photo editor.

Editorial work is very important. Not only might it put you in the position of being a trend-setter; it also functions as significant and cheap PR and exposure. And while it doesn't pay as well as advertising or design work, it is a wonderful vehicle since your work can be seen by the very people you are trying to reach. Clients, account executives, art directors, and buyers all review publications that advertise for their competition and read the articles for trend analysis. Great editorial photography is the creation of the photographer alone, and you can be sure that buyers are always looking at the photo credits.

Think about why well-known photographers are still doing editorial shooting when they can command much larger fees doing commercial assignments. While editorial work may not pay that well in monetary terms, do you really have the luxury to not want your images in front of millions of people?

> **INSIDER INFO FROM THE EDITOR**

This section was written by Rob Haggart, formerly Director of Photography for Men's Journal *and* Outside *magazine.*

The next time you're browsing a newsstand, teach yourself to look at magazines not as a consumer would, but critically, as a potential future client. How do they use photography? What's the quality of their paper stock? Do the photographs reproduce well? How does the color look? Is the advertising of a high quality? Are there a lot of ads? Look at all the magazines in a genre, identify the leader, and then look to see who has the best photography and design. See if they use similar photographers, and look at several months' worth of issues to see if they use the

same photographers over and over. All of this knowledge will be useful as you approach them for work.

Always start by looking at the masthead (located near the table of contents) of the publication you're interested in shooting for. That's where everyone who works there is listed, but note that they're listed in order of authority. People report to the people listed above them. Generally, the art and photo departments have their own sections on the masthead, and you can see who's the boss of each department. The top photo editor usually handles covers and features, the next person down will handle the front and back of the book, and then the next people down or any that are called photo researchers handle stock. Assistants and department managers are great people to call with questions about making contacts and getting submission guidelines.

Once you have done an editorial job, look for the accounts receivable contact info on the business masthead (usually below the editorial one or on the next page) because that's the department that processes your invoices.

Generally speaking, you want to direct your marketing material to the top art and photo people on the masthead, and then direct your in-person contacts to the photography department. While the art directors will have influence on the hiring decision, the photo editor will be doing the hiring, and it's much better if you build your relationship with the photo editor.

An excellent way to get your foot in the door at a magazine is to contact the junior photo editors. They sometimes get overlooked but are often given opportunities to make assignments or find new talent. And don't forget: Someday they will be the top photo editors, and relationships forged on the ground floor can take you a long way.

E-mail is the best way to make initial contact with anyone at a magazine. If the e-mail address is not readily available, ask the receptionist, and if he can't give it out, call the photo editor or art director and request their e-mail so that you can send them a promo e-mail or a link to your website. You can also easily determine someone's e-mail address by looking at the naming convention used on any of the e-mails listed (usually on the business masthead, which lists PR or advertising contacts). If Tom Smith is listed as tsmith@anymagazine.com, or tom.smith@anymagazine.com, or tom_smith@anymagazine.com, then there's a 95 percent chance the person you're trying to reach has an e-mail address that is styled the same way.

When contacting editorial people, there are two very important rules. First, get your facts right. Editorial people are serious about the facts, and you should be too. Did you spell their name correctly? What about the name of their publication? Second, have some basic knowledge about the product they put out, the type of material they might be interested in, and how you fit into that. You don't need to be a fan-boy of the magazine, but interest in the topics it covers helps and will certainly place you above other photographers vying for the same job. Showing interest in the publication in your marketing materials or when you talk to the photo editor on the phone makes him think you are actually interested in creating pictures the magazine's readers will appreciate and not just looking for a job.

The absolutely most important thing about marketing is to make yourself easy to remember, which you can do by emphasizing the things that make you unique. Do you live somewhere interesting? Do you shoot unusual formats? Do you collect something related to the magazine's content? Did you meet someone it did a story on? Tell the photo editor a story she won't forget.

How do I pick a photographer to shoot an assignment? It's an amalgamation of everything: your book, website, tear sheets, clients, awards, personal work, promo card, story in *PDN*, blog, photo I saw published somewhere, a story I heard, our meeting, someone dropped your name, the creative director likes your work, the editor knows your name (possibly a negative), one of my junior photo editors likes your work, the changes in your book since the last time I saw it, you have photos in my coffee shop, the phone message you left, the e-mail you sent that was interesting and personal, another photo editor told me you rock, your hand-shake is solid, the e-mail with a new tear that I think is cool, you care about my magazine (not just the cover and fashion), a gallery exhibit, or a photographer who is your peer recommended you. That's a ton of evidence to consider, but in truth, since I don't write any of it down, it really just adds up to an overall feeling about someone. There is no silver bullet.

A final piece of advice: Work on your craft, steadily contact the people you want to work with, deal honestly and fairly, and the jobs will come.

How to Get Started: Using Databases

Database companies provide lists of contact names and numbers for all of the categories discussed above and more. They provide regular mailer (as in snail mail) contacts and e-mail contacts, as well as account information that can be crucial when you are targeting your list or even when you are asked to bid a project.

Agency Access (www.agencyaccess.com) offers information on thousands of businesses within the United States, Canada, Italy, Denmark, Norway, Finland, Sweden, France, the United Kingdom, and Germany. Their database program is broken out into categories that are easy to

[Top left] Agency Access offers a yearly subscription that will provide you with the names and contact information you need to market yourself. A database subscription costs less than one day's editorial fee. The information is constantly updated, which is crucial for the productive use of your marketing dollars. [Top right] Agency Access allows you to pick the category you want to market to—advertising, in-house, graphic designers, magazines, and other categories. [Bottom left] Agency Access allows you select the titles of the people you want to target. [Bottom right] The database allows you to see the contact names and even an agency's website so you can review the type of work they do and make sure it is a good fit for you. This feature is especially useful when you are searching for design firms. Another great feature is the map icon, which helps you find your way to a person-to-person meeting. Agency Access databases allow you to select the titles of the people you want to target.

navigate. Agency Access offers memberships in e-mail programs that allow you to send e-mails to large groups of people. On an annual basis, you purchase a bundle of names—12,000 or 24,000 or more—to which your e-mails will be sent. Then it's like the minutes on your cell phone: As you do your e-mail send-outs, Agency Access deducts the number of send-outs from your total and keeps a running tab. Also, as with some cell phone plans, there's rollover to the next year. The e-mails are not template-based; in other words, there's no strict format that limits your options in designing the visuals for the e-mails.

Adbase (www.adbase.com) offers information for the United States and Canada. Their e-mail program, called Emailer, has a quarterly expiration date, so if something comes up and you don't use your names during that quarter, you will lose them. You have to use their e-mail templates and cannot design your own.

Other marketing lists—of smaller and more specialized companies— are available as well. Fresh Lists (www.freshlists.com) is one smaller company that offers lists as well; it sells one-year subscriptions that you can update annually. You purchase, by category or location, one-time lists that you download and can use for the entire year. A smaller company may be a less expensive option, but be sure to research their accuracy and find out how often you will receive updates. With smaller companies, you are usually purchasing a list, not a database.

If you have expertise in a specific genre, such as architecture, and want to market to local and national architects, construction companies, and designers, there are organizations that provide databases of contacts within those industries, at a nominal fee. We recommend doing research for additional lists if the mainstream mailing houses noted above do not offer information on everyone in your target market.

Using E-Mail Blasts for Mass Marketing and Follow-Up

E-promos (also called e-blasts) are promotional campaigns conducted via e-mail. They are a great way to do marketing with little financial outlay.

These promotions arrive in a potential client's inbox. An e-mail blast should open within the main window of the e-mail program. The viewer should not have to open any additional windows or do any downloading. The image should be embedded as an HTML file. Once viewers roll the mouse over the image it should appear as clickable; when viewers click on the link, they are taken directly to your website.

The e-mail blast should include your branding (that is, your logo or type treatment), an image that reflects the work you want to be hired to shoot, and your website and contact info.

As Dirk Karsten's e-promo campaign shows, you can feature more than one image or just one, but make sure that all the pieces you send have the same branding. Dirk's e-promo is clean and to the point—with not too many words but a quick link to his website. Make sure your e-promos are less than 1 MB and that they download fast with the image embedded within the main message. Your potential viewers may not take the time to look at images that need to be clicked to or that are attached and need to be downloaded.

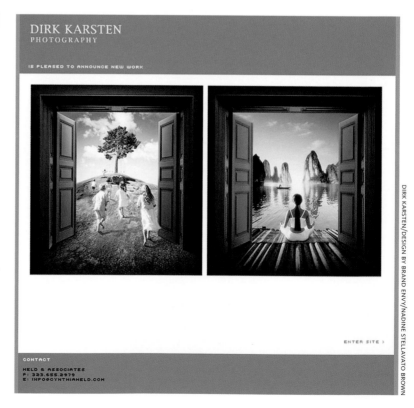

DIRK KARSTEN/DESIGN BY BRAND ENVY/NADINE STELLAVATO BROWN

We estimate that more than half of all photographers have used or are using e-promotions as a form of marketing. Sending a printed card costs about $1.00 per name on average, while an e-promotion usually costs between $0.01 and $0.04 per name. In general, e-marketing yields on average a 1 percent click-through rate, meaning that 1 percent of the people you send to will go on to view your website.

People may say they don't like e-mail blasts, but these are the same people who said they didn't like printed mailers. The reality is that this is the new medium of marketing, and it does get results.

One client sent out an e-mail promo to get the attention of a buyer looking for a children's photographer for a very large, consumer-based client. The photographer got the project, with fees over $15,000—all for

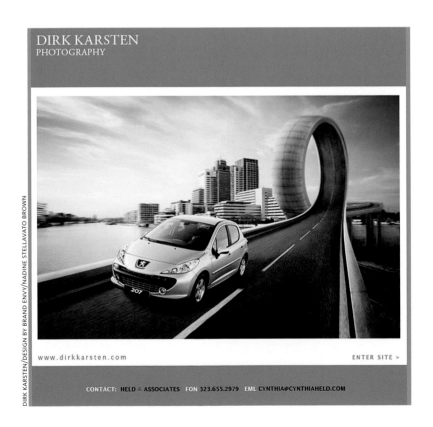

what the e-mail campaign cost. Assuming an e-mail campaign cost of about $600 for 12,000 names, that is a great return on your investment.

Another client e-mailed a promo to an art director in St. Louis, who passed it on to an art director in the photographer's home town—the same art director who hadn't even considered that photographer for a huge consumer beverage project. Today's young creatives like to IM each other and network about who is right for certain assignments.

>> Question

What are your thoughts on e-mail blasts?

>> Answer

Put an image in the e-mail (rather than just a type message with an attachment or download), or chances are I might not see your work. But do not send me huge e-mails with heavy files because my IT department and my laptop do not like that.

—JESSICA HOFFMAN, SENIOR INTEGRATED ART PRODUCER,
CRISPIN PORTER + BOGUSKY, BOULDER

Do not send me an e-mail blast that is over 1 MB. I'm getting way too many of them, and it's becoming difficult to get through my regular e-mail. I wish everyone would use the same subject name protocol so I could sort through them. Maybe start with the word "promo" in the subject line. Sometimes I just have to delete them without looking at them if my mailbox is too full, which happens a lot when I'm traveling.

—KAT DALAGER, SENIOR ART PRODUCER,
CAMPBELL-MITHUN, MINNEAPOLIS

Preparing Printed Promotional Materials

Buyers get e-mails all day long, and the time they spend reading them can be measured in seconds. When a buyer receives a card, he may throw it away, but he also may keep it. E-mails can get buried in a buyer's hard drive, and if that hard drive crashes, the e-mail is gone. Postcards, on the other hand, can be filed away and kept for years.

When you are designing a mailer to create interest in your photography, make sure it shows not only the best of your work but also something that has "sales" value. In other words, you need to show images that will sell products or emotions.

The intention behind a mailer is to motivate the viewer to go to your website and then call in your portfolio or ask you to bid. You need to

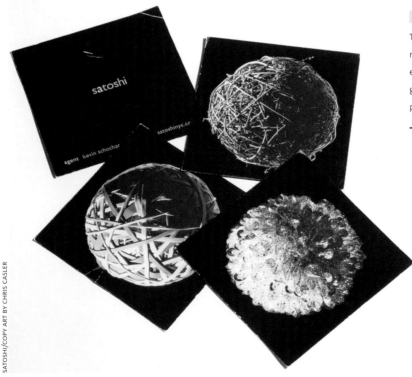

This is a wonderful example of a classic mailer and type treatment. It's more than eight years old and still fabulous. If it's a great mailer, art buyers will keep your promotions.

SATOSHI/COPY ART BY CHRIS CASLER

Lisa Adams created a very clever cam-
paign using the old Animal Rummy card
game. She incorporated the cards in her
work and sent out the mailers over the
course of a year, instructing recipients to
save all the mailers to accumulate a pack
of cards. Not only was the campaign
successful with buyers, it also got the
attention of a great rep. See page 70 for
another image from Lisa's year-long
series.

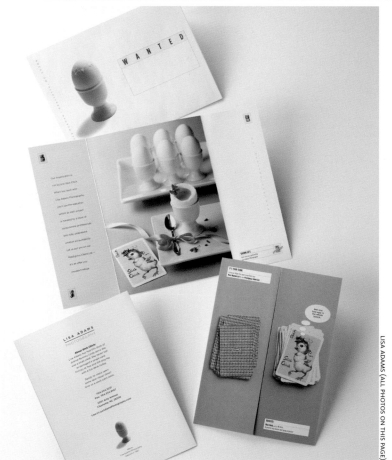

make sure your images and the design of the mailer are strong enough to start the ball rolling.

Getting a click-through report (of people who went to your website after receiving your e-promo) does not mean that these people have jobs for you. However, it does mean your e-promo sparked their interest and got them to visit your site. We recommend that you follow up on these click-throughs with printed mailers. Of course, don't write, "I know you went to my website"—believe it or not, this happens or we wouldn't be saying it. Just send a card printed either on your ink-jet printer or through a printing house. Maybe say something as simple as, "Hope to work with you soon—John."

The image on your follow-up card should be the same image used on your e-promo. With 25 to 50 promotions coming to an art buyer or creative on a daily basis, image recognition is very important. You can also call, but pick and choose those you will contact by phone. Call only the people you would like to meet in person to show your book to.

To produce your printed promotion card, there are many great options beyond your local printer. The suppliers listed below are only a few from the hundreds that are out there.

>> **modernpostcard.com.** This company and other large printing companies generally provide low prices and quick turnaround times, but they usually do "gang-run" printing, meaning they run several jobs at the same time, using the same paper and ink. While gang-run printing can increase the margin for error in terms of color accuracy, it can also produce very nice printed pieces. It's best to provide Modern Postcard or any company that does gang-printing with an accurate proof with a color bar so the printer has something to compare with what first comes off the press. The ideal scenario is for you to be there when the printing is done, to approve the color. If you can't be there, ask for a match print or proof to approve prior to the full run. Working with a proof can add a week or more to the process.

If you want to be eco-friendly and not use an envelope and your designer has created a self-mailer promotion, here is a great option for sealing your promo. The wafer seal is a circular label that holds the mailer together while it is being mailed; it is perforated to allow the viewer to break the seal and view the images inside.

CHRIS CASLER

CHRIS CASLER

>> **paperchase.net.** A great printer that offers different and in some ways more dynamic mailers at "custom" prices, PaperChase can make saddle-stitched and perfect-bound mailers and books as well as conventional folded mailers.

>> **amazingmail.com.** A great resource for a few cards (say, up to 50) that you need to send out quickly. If you are okay with heavy glossy prints, this is a great source.

>> **anchorimaging.com.** This excellent printer is associated with Agency Access. Many feel their quality is comparable to the better-known Modern Postcard.

>> **clearenvelopes.com.** Great alternatives to the traditional envelopes, this company's products let viewers see what is inside and judge whether it is worth opening.

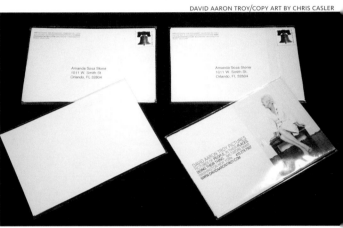

CHRIS CASLER

[Top left] Clear envelopes allow the viewer to see images before opening the envelope. When mailing out your work, make sure the viewer looks at the whole picture, literally. A clear envelope allows your image to show and entice the viewer to open the envelope. Here's a "before" [top right] of one of David Aaron Troy's promotions. The "after" version [bottom] was the result of working with a consultant and designer. Now the addressee sees the image without opening the envelope. An attractive image will prompt most buyers to look inside.

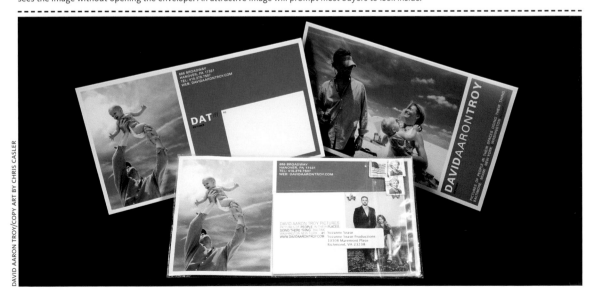

DAVID AARON TROY/COPY ART BY CHRIS CASLER

Seeing your stats is an important factor when evaluating the success rate of an e-mail campaign. A reasonable goal for resulting click-throughs on your website is 1 percent.

This may sound elementary, but be sure to put your name and website on the back of specialized mailers or prints. We say this from experience: We have received beautiful art prints and once we disposed of the envelopes or packaging, the photographer's name and information was lost. As a sad result, these photographers lost out on any number of jobs.

The Agency Access e-mail center allows you to track your e-promo efforts and see the results you achieved. The most important thing to remember is that marketing through mailings needs to be a consistent effort and that it can take considerable time to bear fruit. You may need to send a year's worth of monthly e-mails before a buyer remembers who you are.

Following an e-mail campaign, you can review a click-through report—a list of the people who went to your website.

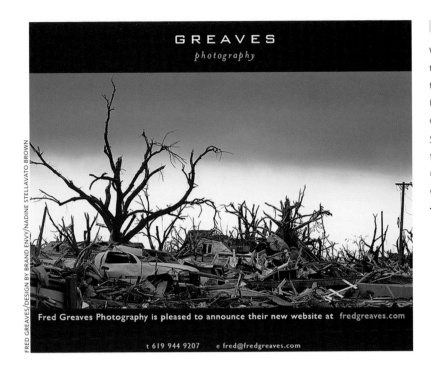

FRED GREAVES/DESIGN BY BRAND ENVY/NADINE STELLAVATO BROWN

When sending out an e-promo, make sure the subject line states that you are a photographer. You can have fun with this, as Fred Greaves does. The subject line that comes up with this image is "So you think you've had a bad day"; the e-mailed image shows the results of a tornado. You are marketing to creative people, so be creative.

>> Question

Why do you believe it is important to market?

>> Answer

Marketing is important to get your name out there. If no one sees your work or knows who you are, how would they ever know to hire you? There are thousands of art buyers out there. If you don't market directly to them, they will more than likely never know who you are.

—NICK ONKEN, PHOTOGRAPHER

What tips do you have for photographers who send out e-mail blasts or otherwise communicate with you by e-mail?

I've been keeping track of how many e-mail promos I receive, which I keep in a separate folder. It's about 15 to 30 every weekday. I highly recommend that photographers use an appropriate subject line when sending e-mail promos in order for me to prioritize what I open. For example, "Food Photography by . . ." will get me to open an e-mail sooner when I'm looking for a food shooter, plus it will help me file and find the e-mail for future reference. If someone is asking for a portfolio review, they should say so in the subject line; otherwise I'll just file it away with the others until I get a chance to open it.

—KAT DALAGER, SENIOR ART PRODUCER,
CAMPBELL-MITHUN, MINNEAPOLIS

Person-to-Person Marketing: Meeting the Client 101

Here is what Rosie Henderson of Best Buy says regarding the value of person-to-person meetings: "Get out there and pound the pavement. Face-to-face is still great. Send a heads up by e-mail, but get yourself out there so that people get to know you and your work."

If you are able to arrange a meeting, make it brief. These folks are very busy, and you must be aware of that. Ten to fifteen minutes and a port-

folio review are all they have to offer. Do not push more work on them or ask for their advice about what your portfolio should look like. If you are too aggressive, no one will want to work with you.

Do not look at someone's personal space and ask about the photos you see or the papers on the desk. Imagine saying to someone, "Is that your child?" only to find out the person is not married and longs to be a mother but hasn't found the right partner.

You are more likely to get an appointment if you are from out of town. Local photographers, who will be around this week, next week, next month, may be in a sense taken for granted and have a harder time landing a face-to-face meeting. When you are local, an agency is more likely to ask you to drop off your portfolio since they know they can set up a meeting with you at any time.

Ask up front what the portfolio policy is. How can you be sure they actually review your portfolio? You can't, of course, but maybe add a little food treat—like a cool Pez dispenser or gummy bears—and a buyer may be more likely to look at your book. It may sound silly, but it works.

Togashi consistently uses strong, stylistic still-life imagery in his marketing campaigns. This e-promo's subject line was "Boobs and Jewels, Real or Fake?" The click-through rate was 13 percent.

HOW TO GET AN APPOINTMENT

If you decide to call to try to set up an appointment, nine times out of ten you will get someone's voice mail. You might have more success by calling and leaving a message, acknowledging how busy the person is, and then following that up with an e-mail.

Do not leave your number and ask a buyer to call you back. Follow up with an e-mail and tell him you would love to show your new book (and if you say this, be sure that it is in fact a new book that he has not seen) and suggest a date and time: "Hey, this is Joe Blow, following up on my message. I know that you are busy, but I would love to take five or ten minutes of your time and show you my new book. Let me know if you are free on Monday or Tuesday of next week at 10 a.m."

If the buyer returns your e-mail and sets up an appointment, be brief with a follow-up and thank him for his time. People respect you more when you respect that precious asset. On average, for every ten calls you make, you may get one appointment. Make the calls and see what your success rate is.

CALLING SERVICES

There are companies out there who will make those dreaded calls for you. One we especially like is Wise Elephant (www.wiseelephant.com). Having someone call for you means that you experience less rejection personally and have a better chance of keeping your ego intact. However, having someone else call also means you don't always know exactly what the person on the other end said or requested. However, if you don't have time and want to meet people or be able to drop off your book, it's worth the cost (anywhere from $3 to $8 per call).

WHAT TO SAY AND NOT SAY

When you get to the meeting, be yourself and let your work speak for itself. Do not talk about your portfolio. Usually the story your images create is better than your story about the shoot. Sure, sometimes the story is better. But wait until you are asked—then you will have a willing audience for your story.

Likewise, do not talk about each image. Let the viewer look at the images at her own pace. If she has questions about the production of some images and you've worked with a producer, let her know that.

Let your host run the conversation. If he seems to be having a bad day, be aware of that and even acknowledge it with a comment like, "Thank you for seeing me. I know you are really busy, so I will be very brief." Never ask what project he is working on that you may be considered for.

And never say, "I could have shot that" when looking at a portfolio in an art director's office. If he thought you could have shot it, he would have hired you! And when you make such a comment, you risk insulting the creative person on their choice of photographer.

If you meet with a creative person or potential client and you connect and they seem to really like your work, consider offering yourself for pro bono work (see pages 106–108 for more on this type of work). Don't, however, come across as desperate, and make sure the work is something you are passionate about.

Stay only five or ten minutes. Again, follow your host's lead and have no expectations of how the meeting will go. Make sure to leave behind a postcard or mailer.

HOW TO FOLLOW UP

Immediately after a meeting, follow up with a nice e-mail or snail-mailed card. Thank the person for taking the time to meet with you and ask her to keep you in mind for any upcoming projects.

Don't expect a call or an assignment right away. You should view the initial meeting as a first step in connecting with a potential client. Then use that connection to build and continue a new relationship.

In the longer term, we recommend a six-month follow-up for all client and industry contacts.

Other Ways to Market Yourself

People say, "If I build it, they will come," or "They will find me on Google." But if buyers don't know you or know exactly what they are looking for, how will they find you? That is where pro bono work and source books (print or online) come in handy. Entering contests is another way to get valuable exposure.

CONSIDER DOING PRO BONO WORK

Some of the best work in your portfolio can be pro bono—short for *pro bono publico,* which means "for the public good." Pro bono is the standard term for work created without charge, usually for a client who does not have a budget to pay for your work; it can be, for example, public service advertising or work for a nonprofit. You might work in partnership with an art director who wants to get work produced to enter into the award shows and contests; the credit for such an image might read, "This image was a collaboration of James Martin, Art Di-

CHRIS DAVIS

WHAT Would You RATHER SEND YOUR HEADHUNTER? REPRINTS? OR PAGE Numbers?

Now available at Tower Records. Books and music for creative people.

One of the best ways to get exposure is to work pro bono (without charge). Art directors seem to do their best work pro bono, and such work often gets into the award shows and contests. Even though you are not paid for the work, it allows art directors to see your style and how you work. This image by Chris Davis won an award in *Archive*, a highly respected international publication.

rector, and Chris Davis, Photographer." Please note: We recommend working this way only when it will benefit you professionally. We are not suggesting giving your work away for free.

In most award shows and contests, the pro bono work receives more awards since it is not always client-dictated. The award book will display a photo credit, so it's a great way for you to get your name out there. Also, this is a great way for an art director to see how you work without risking the client's money. Many photographers and art directors have

formed strong bonds and long relationships by doing pro bono projects together.

If you are having a hard time coming up with ideas for a photo shoot, ask a local art director to work with you outside of his agency on his own—for barter, for free, or for compensation—to help you create concepts. It may cost you, but the result could be well worth it.

For editorial work (photography that accompanies a story in a magazine or newspaper), shoot subjects that mean something to you. Magazines prefer stories featuring multiple images rather than single-image entries. If you want to be considered for a feature story, you need to show the magazine that you can carry a single idea or theme through several images.

For fashion images, you could create a story based on makeup, a theme, or an item. If you are a food photographer, create a story around something like chicken, herbs, or a culinary style. Travel photographers can create a story on location that makes the viewer want to visit that place.

PRINTED SOURCE BOOKS: BUT ARE THEY DYING?

If a buyer is looking for a portrait photographer in Colorado Springs, source books make it easy to go to a location and search by specialty. But printed source books—annual and semiannual hard-copy industry directories made up of pages of advertising by photographers—are beginning to feel like a thing of the past.

However, it may be too early to count printed source books out. We know of photographers who have advertised year after year in printed source books with a great rate of return on their marketing dollar. In

addition, source book houses are trying to re-create the need for and appeal of printed source books.

To help you decide whether to advertise in a printed source book, follow your current market. Ask your current and potential audience of buyers if they use printed source books. Being included in one is expensive ($3,000–$5,000), and if it is not going to bring in work, don't waste your marketing dollars. Never be pushed by a sales rep to purchase space in one or more of these books. Instead, decide what is best for you.

The most important printed source books include *Workbook, Alternative Pick, Black Book,* and *Le Book.*

ALTERNATIVE PICK/COPY ART BY CHRIS CASLER/IMAGES FEATURED BY LENNETTE NEWELL, WALTER LOCKWOOD, AND PETER BARRETT

Alternative Pick sent buyers something special for viewing their clients' work. The deck of cards was a brilliant way to send buyers images in a functional presentation that was compact enough to store.

ONLINE SOURCE BOOKS

Online source books are emerging as the way for today's photographers to present their work. They offer an easy way to be found, and many photographers no longer use printed source books, but now use online guides exclusively.

A simple listing in an online source book can be free, or you can spend anywhere from $600 to $1,500 for an online portfolio and hyperlink.

Some of the most important online source books are:

>> www.workbook.com. Many consider this the industry bible.
>> www.photoserve.com. Photoserve features "selected" galleries that are chosen based on recently uploaded and edited images. The best way to be one of the featured galleries is to change your gallery monthly.
>> www.blackbook.com. Web portfolios are available as part of a print package and/or separately.
>> www.at-edge.com. Being invited to participate in this site—the online partner of AtEdge, an award-winning series of publications— puts you in the company of the world's best assignment photographers.
>> www.altpick.com. First recognized for its work in the music industry and for being very creative, this online source book (along with the printed book) has now expanded to reach a broader market.
>> www.lebook.com. To appear in the online version, you must also be in the printed book (great for fashion or beauty photographers).
>> www.asmp.org/findaphotographer. ASMP's online resource is a valuable benefit to ASMP members.

Workbook offers a great online source book targeted to buyers who can review your work based on your specialty or location. They will also list you for free—but just your contact info, no images.

PhotoServe offers the same thing as Workbook. Frequently updating your work on the site increases your chances of appearing at the front of the list in your category.

CONTESTS

We encourage our clients to enter photography contests for the exposure they bring. The more people who see your work, the better. With some contests, only the winners are published and recognized, but in others, multiple finalists are featured, and photographers can get the intangible recognition as well as tangible prizes in the form of equipment and marketing.

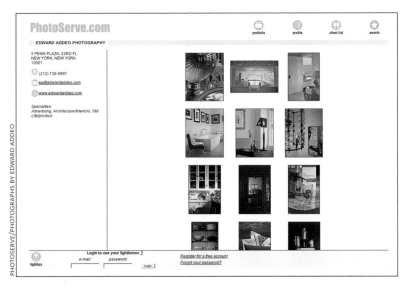

PHOTOSERVE/PHOTOGRAPHS BY EDWARD ADDEO

ASMP's "Find a Photographer" feature allows you to post your images as a part of your ASMP membership. Buyers use this database of images when looking for a photographer in a certain area.

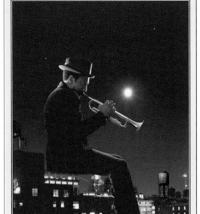

Return to search results.

ASMP Member Profile:

Leslie Jean-Bart

We create visual ideas as well as portraits for a variety of editorial clients and record companies. Our editorial clients have included Harper's Magazine, New York Times Magazine, Publishers Weekly, Scholastic Magazines, Verve Music Group (UMG).

ASMP Chapter: New York

Contact Info

310 West 107th Street
New York, NY 10025

(212) 662-3985 **Work**

jeanbart@earthlink.net

If this is your ASMP profile, you may make updates using the Member Database.

Specialties

- People: Portraiture
- Multi-Media
- Editorial
- People: Celebrities / Personalities / Entertainment

Metro Areas

- NY: New York City-Northern NJ-Long Island

Portfolio

ASMP/PHOTOGRAPHY BY LESLIE JEAN BART

How often do you use the online source books vs. the printed books.

I don't use either. I use my promos and my bookmarks. I have book-marks for most of the reps, and I will use these sites first. I don't like how the online source books are set up. I'll look at the printed work-book before I'll go to the online sources, but the direct sites are always first.

—ANGELA LEWIS REID, SENIOR ART BUYER,
DRAFT FCB GROUP, NEW YORK

I use the online source books more. I know them a little better, and they are obviously updated more often, whereas a book on my shelf remains unchanged. Also I can reference the online stuff anywhere (home, work, etc.). I do, however, also reference the printed books and just make sure that I keep only updated volumes.

—TIFFANY CORREA, ART BUYER,
PUSH, ORLANDO

I tend to use both because I want to weigh my options.

—JACKIE CONTEE, FREELANCE ART BUYER;
FORMERLY ART BUYING MANAGER FOR BRAVO, NEW YORK

I use PDN online, Workbook, and on occasion BlackBook or LeBook. Printed source books are good to have but are needed less and less. They just aren't as easy to use as the Web these days.

—JESSICA HOFFMAN, SENIOR INTEGRATED ART PRODUCER,
CRISPIN PORTER + BOGUSKY, BOULDER

Printed source books are great for knowing who's out there and what they are doing. But after the initial run-through, a printed book usually gets shelved and is used rarely.

—ROSIE HENDERSON, SENIOR ART PRODUCER, BEST BUY, MINNEAPOLIS

Bottom line: There is no one answer. So it's always best to cover yourself and appear in places where at least some buyers will look.

Contests are difficult to get into, but they are the "bibles" for art directors to see what their peers have chosen as the best. If you don't get in, no worries—just keep trying. Getting in doesn't mean that you are going to hit the big time, either. Instead of expecting that to happen, you should use the recognition as a press release advantage. In other words, take the bull by the horns! Most well-known photographers have used the PR factor (even writing their own press releases) to get their names out there.

It would also be beneficial to send copies of the award book to about 25 people you have wanted to work with. Make sure to have your image page marked.

Among the best forms of advertising are contests targeted to art directors. Some of the biggest are those run by the website Photoserve and by the magazines *Communication Arts* and *Archive*. The judges are looking for great images that sell. Remember, these folks are used to hiring photographers for their clients. We have actually seen art directors use the award annuals as source books. One client bought extra copies of the annual he appeared in and sent them to his dream clients with his images highlighted. This tactic kept him very busy with new clients and assignments.

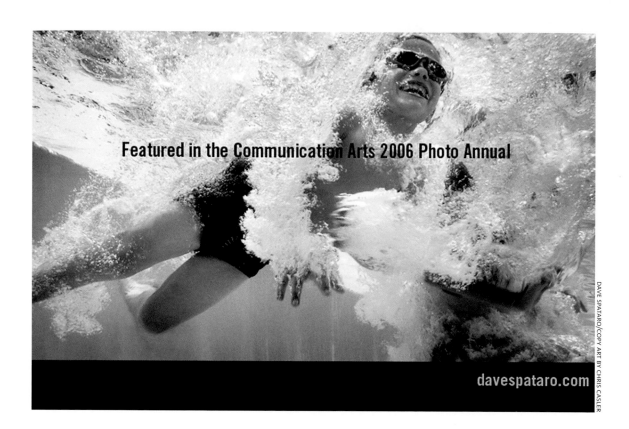

Featured in the Communication Arts 2006 Photo Annual

davespataro.com

When you are fortunate enough to get into one of the prestigious contests, make sure to let people know. Dave Spataro sent out this e-promo showing that he got into the *Communication Arts Photography Annual*.

Workbook.com is one of the best resources for finding contest dates; go to www.workbook.com/site_map and, under Database, download the Events and Contests PDF. Meanwhile, here are the top contests and the month when they usually set the deadline for entries.

Archive. This is one of the hottest places to have your work featured. www.luerzersarchive.us/submission.asp

Photo District News (PDN) Magazine's Photo Annual
Deadline: January
www.pdnonline.com/contests

Communication Arts (CA) Photography Annual
Deadline: March
www.commarts.com/competitions/photography

What mailers stand out for you? What was something special?

I still love mailers. It's easier to sort through to see what I'm looking for than it is to sort through a non-visual list of website names to find someone. Postcards are fine, but I prefer something with more images on it.

—KAT DALAGER, SENIOR ART PRODUCER,
CAMPBELL-MITHUN, MINNEAPOLIS

Excellent photography will always stand out. Repetitive mailers can overload the inbox and be frustrating, but you do remember who the photographer is.

—ROSIE HENDERSON, SENIOR ART PRODUCER,
BEST BUY, MINNEAPOLIS

I like mailers that feature interesting work that doesn't feel like it's been around for ten or twenty years. I like receiving mailers and keep a lot of them.

—JESSICA HOFFMAN, SENIOR INTEGRATED ART PRODUCER,
CRISPIN PORTER + BOGUSKY, BOULDER

PIX Digital Imaging Contest

Deadline: August

www.pixdigitalimagingcontest.com

International Photography Awards

Deadline: June

www.photoawards.com

Graphis Design Annual
Deadline: March
www.graphis.com

Graphis Advertising Journal
Deadline: July
www.graphis.com

Graphis Photography
Deadline: August
www.graphis.com

Planning a Year at a Time

Create a marketing plan that both considers the details and looks at the big picture. The best way to start is to plan for monthly marketing activities that will take place over the course of a year.

The sections below form a "template" marketing plan that you might want to consider, with your own modifications and adaptations. Use them along with the Annual Calendar shown in the illustration.

>> **Question**

How does someone who is unknown get work?

>> **Answer**

Become known. PR, PR, PR. Getting into CA *or* PDN *is worth gold.*
—KAT DALAGER, SENIOR ART PRODUCER,
CAMPBELL-MITHUN, MINNEAPOLIS

ANNUAL CALENDAR

	A LIST DREAM CLIENTS	B LIST MASS MARKETING	C LIST HUMAN CONTACT	D LIST EXISTING CLIENTS	E LIST MISC
JANUARY	Conceptualize 4-part campaign	1/1 e-promo — #k contacts + follow up with click-through report	Meet with 1 new person & 1 existing contact or client	Prepare existing client list & industry contacts	Create follow-up card & update website
FEBRUARY	Create materials	Printed promo to #k of contacts	Meet with 1 new person & 1 existing contact or client		Shoot
MARCH	Send first part of campaign	3/1 e-promo — #k contacts + follow up click-through report	Meet with 1 new person & 1 existing contact or client		
APRIL			Meet with 1 new person & 1 existing contact or client		Shoot
MAY		5/1 e-promo — #k contacts + follow up with click-through report	Meet with 1 new person & 1 existing contact or client		
JUNE	Send second part of campaign		Meet with 1 new person & 1 existing contact or client		Update website
JULY		7/1 e-promo — #k contacts + follow up with click-through report	Meet with 1 new person & 1 existing contact or client		
AUGUST		Printed promo to #k of contacts	Meet with 1 new person & 1 existing contact or client		Stock
SEPTEMBER	Send third part of campaign	9/1 e-promo — #k contacts + follow up with click-through report	Meet with 1 new person & 1 existing contact or client		Gallery show
OCTOBER			Meet with 1 new person & 1 existing contact or client		
NOVEMBER		11/1 epromo — #k contacts + follow up with click-through report	Meet with 1 new person & 1 existing contact or client	Update client list — Plan holiday gifts	REVIEW 2008
DECEMBER	Send fourth part of campaign		Meet with 1 new person & 1 existing contact or client	Holiday gifts: $XXX	PLAN 2009

The dates that appear are estimated dates. Work with your database company to set the actual dates for mailings.

To keep yourself on track, record all your marketing efforts on a calendar. Make sure you look at the big picture (the whole year) not just one month at a time. (The CD provided with this book includes a downloadable calendar template; see Appendix B.)

- -

A-LIST: DREAM CLIENTS

Using your own personal research and/or with the help of a database company like Agency Access, create a list of the dream clients that you would most like to work with. For the best relationship building, target only one person per company.

Four times a year, create a single, dynamic, printed promotion, or other unique, consistent piece that you will send to this list. Make sure that your A-list campaign shows your style consistently so that after a year's time you will have become identified in the clients' minds with a particular photographic style.

B-LIST: MASS MARKETING

Create an e-promo that has the "Wow!" factor. Send it out six times a year to either your own list or one you buy from a database company

like Agency Access (www.agencyaccess.com; ask Keith Gentile or Dan Caruso to give you a demo and pricing).

If you work with a database company, you will receive a click-through report. Send follow-up postcards that can be done on your printer or through companies like AmazingMail (www.amazingmail.com). Do not ask the contacts if they remember your e-promo and do not tell them you know they went to your website. But you can add a personal note on the card, saying something like, "Hope to work with you soon," and signing your first name.

If you can afford it, mail a printed promotion twice a year to the same list, always striving for the "Wow!" factor.

C-LIST: NEW PERSON-TO-PERSON CONTACTS

Meet with one or two new people per month. At the end of the year you will have made between 12 and 24 new contacts. To get an appointment, call and leave a message something like this: "This is Jane Doe, and I would love to set up five to ten minutes to meet with you in person and show you my latest portfolio. I know you are busy, so I will follow up with an e-mail."

› WHAT IS THE "WOW!" FACTOR?

A promo piece with the "Wow!" factor is the polar opposite of a boring, one-sided postcard with an address on the other side. It speaks the language of your potential clients, giving them a solid idea of what jobs to hire you for, and is interactive and engaging. A mailing with the "Wow!" factor is a "keeper" that potential clients will pin to their bulletin board or file away for future use.

When you follow up, make the subject line of your e-mail something like "Following up." Then write a message along these lines: "Hello. I would love to set up five to ten minutes to meet you in person and show you my latest portfolio. Let me know if you are available next Monday or Tuesday at 10 or 11 a.m. Cheers, Jane." You can also include a photo in the e-mail.

D-LIST: EXISTING CLIENTS

Whenever you complete a job for a client, write a thank-you note. Keep a list of all the clients you've worked for that you want to keep. Plan to follow up with them consistently two months after your last contact with them. At the end of the year, send holiday acknowledgments of appreciation (cards, prints, and/or gifts).

E-LIST: MISCELLANEOUS AND CONTESTS

Keep track of important details that otherwise might "fall through the cracks"—updating your website, doing creative shooting, selling to stock houses, and organizing a gallery show. At the end of the year, be sure to review your activities over the past months and plan for the coming year.

Also review the various award shows and contests (see pages 112–118) and choose several to enter each year. Use your calendar's miscellaneous column to remind you about the entry dates.

SOURCE BOOKS

Contact the source books and online resource guides (see pages 108–115). Ask if you can be listed for free, and inquire about the cost of buying space for display of your work.

04

BIDDING THE JOB

WORST-CASE SCENARIO: AN AGENCY ASKS YOU TO BID A JOB, BUT YOU HAVE NO IDEA WHERE TO BEGIN. YOU CALL YOUR MOM AND ASK HER WHAT YOU ARE WORTH. YOUR MOTHER SAYS YOU ARE PRICELESS.

At the end of the day, your mother's opinion won't help with your estimate, but it will reinforce this important fact: Your work is valuable and you should charge for it.

Write down what your day rate is for editorial and what it is for advertising, and be prepared with those numbers before that first job opportunity ever comes in.

The national average for day rates is so vague that it's hard to give firm advice. In today's market $2,500 to $6,500 per advertising job is about average, and for editorial work the average currently is $800 to $1,200 (not including a cover shoot). But in some markets people will give away the farm (a complete buyout) for an $800 day rate. We do not support this.

Your monthly overhead can help you set your daily rate for advertising work. If it costs you $3,500 a month to run your studio, you should have a good idea of what your day rate should be.

Help your market and your value grow by raising the bar and encouraging your peers to charge for their worth, too.

Professional Estimates and Triple Bids

A professional bid shows the art buyer, client, or editor that you understand how to produce a job within a budget. When a budget is not provided (which is more common than not), a professional bid shows your ability to produce a job within the scope of industry standard rates.

Most agencies require a triple bid, which means you are bidding against two other artists. There are two common types of triple bids. In the first, three people of similar talent are asked for bids; this type of triple bid is a way to allow the client to pick one photographer over the other.

The second type—calling in a low bidder and a high bidder—allows the middle bid to be the first pick of the art director, the visionary who comes up with the concept and is usually the one who sells the client on a particular photographer. A good art buyer knows who to call in for a low and high bid; they can tell either by the quality of the work or from their past bidding experiences with that vendor.

Try to be aware of the types of bids you might be involved in. Don't ask, but do listen and be aware. Once the bidding is complete and if you did not get the job, you can feel comfortable asking the art buyer what the deciding factor was—creative, financial, or both. Once you ask that question, don't ask any additional ones, and be prepared to think about the answer and learn from it.

Do your research. You can always negotiate your rate after hearing a project's specs, and if it's worth it to you to bring your fee down, then

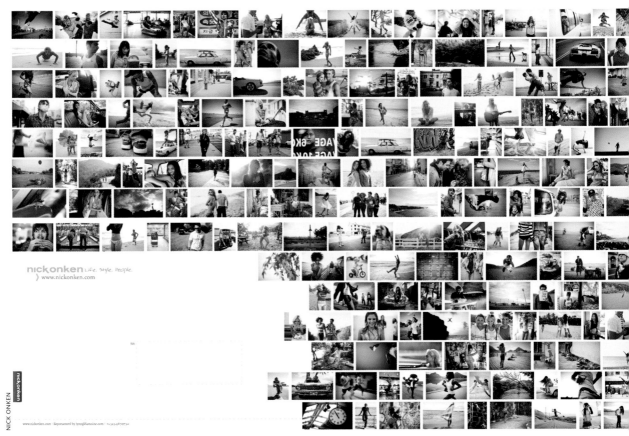

nickonken Life. Style. People.
www.nickonken.com

www.nickonken.com : Represented by lynn@llantoine.com : +1.323.4670730

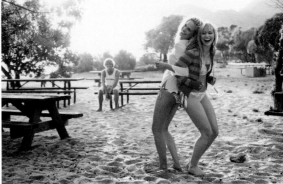

NICK ONKEN

Nick Onken makes sure his design is always top-notch and that it complements his brand. Good marketing like this will put you closer to bidding on the jobs you want.

- -

do it. Just be sure that when you do that, the job is beneficial to you in other ways besides money.

Bidding: What You Need to Know

The art of bidding—and perhaps negotiating to bring a bid into line with a client's expectations—is a skill that experienced art buyers have perfected. Meanwhile, you may be asked to provide an estimate and have no idea even where to start to produce the project.

Should you ask the agency or the client for a budget? After a few estimates, you will know whether you would benefit from asking for a budget. Some people are able to bid more effectively when a budget is provided, while others find a budget to be restricting when they are trying to produce a job creatively.

One thing you can do is to turn to a producer. The best way to find a great producer is to ask other photographers who they would recommend. Professional organizations like Advertising Photographers of America (APA) and American Society of Media Photographers (ASMP) are also great ways to network for these contacts. (See advice later in this chapter about hiring a negotiator.)

If there is already a producer on the project, it is really important to talk to him or her to make sure the two of you will "click" since you will be partnering with them on the set for anywhere from a single day to several weeks. Often the producer can produce the entire estimate for you, except for your fee.

At the least, a good producer will have an idea of fair market numbers for crew and expenses. Of course, you will have to confirm the producer's estimates, and then you must also add your cost to the total.

Estimate Questionnaire

Today's date _____
Estimate due _____
Name _____
Art buyer _____ Art director _____ Other _____
Art director's direct line _____ e-mail _____
Address _____ ☐ agency ☐ design ☐ editorial ☐ other
Phone _____ Fax _____
Project _____

☐ B/W ☐ Color ☐ Digital ☐ Deliverable format _____
Can we talk with the art director? _____
Do you have a bid sheet? _____
Do you have layouts? _____
Budget: $_____
Usage: ☐ print/magazine ☐ newspaper ☐ out of home ☐ collateral ☐ point of sale
 ☐ electronic ☐ TV ☐ other_____
Time frame _____
Territory _____
Optional uses needed on estimate_____
Film: ☐ B/W ☐ Color ☐ B/W & color
 Prints needed and what size _____ Range _____
Casting: ☐ actual ☐ digital ☐ Polaroids ☐ comp cards ☐ website
 Talent specs: sex ___ race _____ age ____ budget range _____
 Talent specs: sex ___ race _____ age ____ budget range _____
 Talent specs: sex ___ race _____ age ____ budget range _____
 Casting due _____ website_____
Location: Scouting ☐ yes ☐ no Where? _____
 Location scouting due _____ website_____
 Travel: Include costs for the agency? ☐ yes ☐ no
 Van rental for equipment: ☐ yes ☐ no
 Car rental: Photographer ☐ yes ☐ no Agency ☐ yes ☐ no
 Motor home: ☐ yes ☐ no
 Hotel booking for agency: ☐ yes ☐ no How many people? _____
Stylists:
 Hair: ☐ yes ☐ no Makeup: ☐ yes ☐ no
 Wardrobe: ☐ yes ☐ no Style of wardrobe per talent _____
 Needed on set? ☐ yes ☐ no
 Props: ☐ yes ☐ no Items needed _____
 Prop stylist needed on set: ☐ yes ☐ no
Meals: How many agency/clients on set? : _____ Dietary restrictions _____
 How many days? _____How many meals per day? _____
 How many agency personnel? _____How many crew? _____

Final fee on estimate $ _____
Final estimate submitted $ _____ Estimate submitted (date)_____
Job awarded? ☐ yes ☐ no
If no, it was awarded to _____

When you get a call to estimate a job, here is a great arsenal of questions to have ready. Have these pre-printed next to your phone. (The CD included with this book provides this form.)

When bidding a job and working with a producer, have your producer approve the estimate you work up before you send it off to the client.

BE READY

You are sitting at your desk and get a call inviting you to bid on a job. Instead of panicking, reach for our handy Estimate Questionnaire (page 127). Start by writing down what the creative/buyer/editor is telling you. Then ask some questions of your own about things he has not covered. Being able to ask those questions will help you better estimate the job.

One of the most important pieces of information to get in such a conversation is how the image will be used—in other words, the usage terms. You need to know exactly what you are negotiating.

Understanding usage terms is vitally important. Not only should you charge your day rate for commercial jobs, you should also charge a usage fee based on where the image is going to run, how long it will run, and the exposure (how many people it is estimated will see it). See Appendix A: Terms to Know and Understand: Usage Statement Guidelines for Photographers (page 187).

Clients always say, "Well, the budget is low." Well, it's up to you how to respond. Here's what you can say to a client who says he has a small budget: "I appreciate your budget, and I will be happy to estimate the project for what it would really cost to do what you want."

CREATIVE FEE VS. DAY RATE

Suzanne prefers a "creative fee" (a flat fee) over a "shoot and usage" fee (based on time spent and usage of the images) since any additional usage would be calculated as a percentage of that higher flat fee.

Amanda prefers the "creative fee" as well. However, through negotiating as a photographer's rep, she learned that she could sometimes get better rates by breaking costs out into day rates and usage fees.

There are times when the photographer presents his fee as one flat creative fee, and then at the last minute, a cost consultant asks for a breakdown. Clients (but usually not agencies) sometimes hire cost consultants to review vendors' estimates.

Working with cost consultants can be challenging because they are very good at looking at each line item and dissecting the bottom line. You need to be prepared to break your creative fee down into a shoot day rate, pre and post day rates, and usage fees.

At the outset, try to judge whether the project has the possibility for "retainer usage" or "legs," which means additional usage beyond what was originally negotiated and the potential for more money for you at the expiration of the stated time frame.

USAGE RIGHTS

Usage costs reflect the amount of exposure an image will receive—the greater the exposure, the higher the cost. An array of considerations qualify the usage of a particular image—time period; whether rights are

limited, unlimited, or there is a total buyout; exclusivity; geographic region; market; usage category; and media.

Meanwhile, here are some examples of usage rights that a photographer might contract for. The wordings below are the way terms would be worded for an estimate or invoice. For a fuller explanation, see Appendix A: Terms to Know and Understand: Usage Statement Guidelines for Photographers (page 187), a thorough rundown of the terms and concepts you'll need to be familiar with when negotiating a contract.

Usage: One Year, Unlimited Insertions & Circ., North America
Media: Trade and Consumer Print

Usage: 1 insertion, 5MM circ, New Jersey
Media: New Jersey Digest

Usage: 6 months, 5 locations, Tri-State Area (NY, NJ & CT)
Media: OOH ("out of home" = billboards)

Many companies are asking for complete buyouts of anything from one image to entire libraries. To provide this usage without giving away your copyright, write the usage as "Unlimited Use in Perpetuity."

Be very careful and aware of buyers asking for rights to the "body of works." This means everything shot—not just the final image(s). If you agree to include this wording in your estimate, you will not have stock rights to the outtakes.

It is close to impossible to get a copy of the media buy, but that does not really matter since your fees are not a percentage of the media buy, as some photographers think. If you want to lose a job for sure, be a pain about the media buy. In many cases, agencies do not do the media buy. Instead, the clients have a media service, so the agency does not get a percentage of the buy either. Also, just because a buy may be

large, it is not the agency's or client's fault that large magazines or newspaper publishers charge what they do for media space.

LINE ITEMS

Your estimates and invoices should show separate line items that are standard in the industry.

Get ready for one of the most controversial statements we will make in this book: We strongly encourage you not to mark up crew fees and expenses. Many say that a 20 percent markup is the norm; however, in our experience (we come from the agency side), marking up costs is not an acceptable practice.

Charging the client $400 for an assistant and then paying that assistant only $250 does not sit right with us. In the age of film, markup was acceptable—you not only paid for film and processing but also had to deliver and pick up the film and edit it. Today you charge a digital capture fee for that added work.

We strongly recommend that you not "doctor" receipts to add a markup. Most clients want original receipts anyway (and you should keep copies).

Ask yourself, "If my client asks me about my markups, will I be comfortable explaining them?" If you feel you will be comfortable doing so, then mark up your costs, but if not, bill the client without adding to your costs.

While film and its processing have long been a "profit center" on photography projects, you can also recoup your costs for digital captures and processing. (If you are not an expert in digital, many clients are fine

with a digital technician on set.) Be sure to purchase two external hard drives—one for the client and one for yourself—and add this cost to your estimate. But check the tax laws in your state to see if by providing the client with an external hard drive (rather than submitting the images via an FTP site) you make the entire project taxable.

We recommend that you bill the following as line items. You or the producer should create estimates for the following areas and show them as line items on the estimate and on the invoice at the end of the shoot.

>> **Pre-production days.** These are days you are using to prepare for the shoot. You should be paid for this time. Many photographers charge half of a day rate for this.

>> **Post-production days.** This is when you convert the captured digital images to printable files. Considering how much time this can take, clients are increasingly realizing they should pay for this—up to 50 to 100 percent of a photographer's creative day rate.

>> **Tech scouting.** Prior to the shoot you'll need to visit the location at the exact time of day when the shoot will take place in order to plan for any problems or challenges before the client and crew are on set. You can charge up to 50 to 100 percent of your creative day rate.

>> **Digital capture/digital proofs.** In the digital era, this replaces the charge for film processing. Some photographers set a flat rate, while others charge by the number of shots (because of different locations or setups). For editorial work, the charge might be $50 to $250 per capture; for advertising images, it might start at $50 per capture but extend to thousands of dollars per capture.

>> **Digital archiving.** Your charge for storing your client's artwork depends on the hard drive you have purchased and what you feel is a fair fee to store the imagery for an extended period of time. Many companies store devices like this offsite for you. You can charge clients a flat fee for this service.

>> **External hard drives.** Many clients want photographers to put all their images on an external hard drive.

>> **Your equipment and/or your studio.** You can charge for the use of your own equipment if you appropriately estimate for this up front. We recommend charging close to what rental houses charge or less.

>> **Paid assistant/staff.** If you have in-house employees, you should bill your client for their services, even if they are on salary. It's a business expense and the same as charging to rent your studio. Charge $150 to $800 a day depending on the job and the assistant's expertise.

>> **Locations.** Usually the photographer is required to find (scout) the location and get all permits and releases. On some jobs the client specifies the location and gets the clearances. Make sure you estimate for any costs, and include permits, if needed.

>> **Recreational vehicle (RV).** Always make sure you estimate for overages and tax percentages. If you are shooting at a business or residence, it is crucial that you have an RV.

>> **Talent.** Models typically charge either a day rate and usage plus 20 percent, or a flat fee plus 20 percent. Make sure the client is invoiced and paid so you have no liability on workmen's compensation and unemployment issues.

>> **Welfare worker/teacher.** Check state rules on your responsibility for minors. For example, in California, when children are on a set, a welfare worker or teacher has to be present for the safety of the minor, even if the parents are on set.

>> **Craft services.** Snacks and drinks for the crew.

>> **Catering.** Be sure to know how many people will be on the set for meals, and be conscious of any eating restrictions. Know the difference between vegetarian and vegan. Bone up on gluten-free foods and nut allergies.

>> **Wardrobe and props.** Ask your stylists for appropriate fees (they may be responsible for making purchases). It's very important that stylists and the producer keep accurate lists of what was purchased and returned. Also ask the client where non-returnable items should be sent or where they would like them donated.

>> **Per diems.** These crew fees for food and expenses are usually charged for production days or for non-catered crew meals (commonly used in editorial estimates).

How do you feel about markups?

The most common reason photographers give when defending a markup on their invoices is that it compensates them for covering expenses and the associated administrative costs that may have to be paid prior to receiving payment from the client. If a photographer receives an advance payment on invoices, he should charge no markup since the advance payment should cover expenses. A photographer's fee should cover his cost of doing business as well as his time/value. This includes making sure that his fee covers administrative costs that are not typically broken out in an invoice, such as bookkeeping, utilities, photocopies, etc. Explaining that certain line items, such as talent and stylists, will be marked up if there is no advance payment is one way to introduce the topic of advance payment to uneducated clients at the estimating stage.

In the age of digital photography, the "digital processing fee" has become the invisible markup category, much as "film and processing" was in the past. Sometimes I wonder if I'm paying $600 a day for the same $250-a-day assistant to upload files.

—KAT DALAGER, SENIOR ART PRODUCER,
CAMPBELL-MITHUN, MINNEAPOLIS

- **>> Lodging and travel.**
- **>> Insurance.** Many locations require proof of insurance. Some agencies are starting to offer insurance per shoot.
- **>> Mileage.** Check the IRS's current standard mileage rate (in 2008 it was 50.5 cents).
- **>> Cell-phone usage.**
- **>> Shipping.**
- **>> Miscellaneous.** Anticipate an amount by which your final purchasing may exceed the estimated budget.

In the end, when confronted with decisions like these, always do what feels right to you.

THE CREW

The crew is the group of people who make the shoot happen. The crew you select represents you, so be sure that you like and respect everyone you bring onto the set, and, of course, be sure that they are the right people and will do a great job. Most crews are established by either the photographer or the producer, or by the two working in tandem.

> The Producer

The producer is the business manager on a project. He or she will be your invaluable partner during the estimating process, pre-production, on-set work and shooting, and post-production. A good producer is there to back you up and make the shoot go as smoothly as possible.

Photographers typically choose their producers; however, agencies sometimes have a producer in mind. You should have a relationship pre-established with two or three producers, so that you will be ready to estimate and book them when a job comes in. If a client wants to use

their own producer, you might not have this access to the producer for estimating.

A good producer should have great people skills and should be organized and resourceful. In addition, producers should be skilled in:

>> **Estimating.** Working with the client's rep, the photographer, and the crew.
>> **Coordinating.** The pre-production meeting, pre-production call sheet, and production book are all the producer's responsibility.
>> **On-set support.** The producer should be either on location or available via phone during a shoot.
>> **Organization.** The producer is responsible for the administration of everything from food and lodging to weather and transportation.
>> **Handling paperwork.** Model releases, property releases, signed overage forms, receipts, and crew payments are overseen by the producer.
>> **Invoicing.** The producer categorizes all receipts and adds them up.

Even before you have a job or prospects for one, do some solid research on producers available in your area. Call and interview a few producers and try to come up with a short list of people you might want to work with on a commercial or large editorial job.

A producer can be the most important person in your crew, as he or she will manage the rest of the crew and all the incidentals for a project. Your producer should be an experienced person who has handled many different assignments and knows the ins and outs of what it takes to produce a shoot.

A producer will estimate or help you estimate all the expenses for the project, except for your fees. Always work with producers on their estimates to make sure they don't overestimate the project.

See Appendix B for a downloadable Estimate Check-Off List that you and the producer can use in compiling an estimate. Such a list is particularly useful for large jobs with many different elements to estimate.

> ### *Other Crew Members*

The makeup of the rest of the crew—generally hired by the photographer and/or the producer—will depend on the nature and size of the shoot. Here are some typical crew members you might work with on a large shoot:

>> **Assistant.** An "all around" person to help you with all shoot needs—lighting, cameras, etc.
>> **Grip.** The lighting assistant.
>> **Digital tech.** He or she receives digital files from the camera, transfers files, and works on retouching and processing on set.
>> **Location scout.** A person or company who finds locations based on a client's specs or requests and who is usually also responsible for getting permissions and for pulling permits.
>> **Stylists (makeup, wardrobe, groomer).** Not all shoots require all three. It's the responsibility of the stylist(s) to make sure the talent looks well put together.
>> **Stylist assistant.** A person who assists the stylist(s).
>> **Prop master.** He or she builds props for the set that are unusual, unique, or not available for rent or purchase.

Using Estimate and Invoice Templates

Make sure that your estimate looks professional. Using Blinkbid (www.blinkbid.com) is an inexpensive way to estimate your project and invoice it too. A QuickBooks estimate always looks unprofessional and non-designed (unless you are a consumer photographer charging a flat fee).

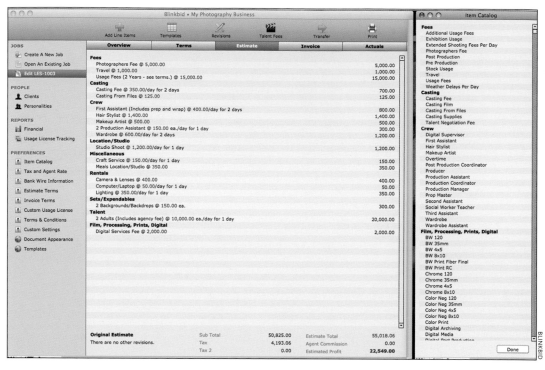

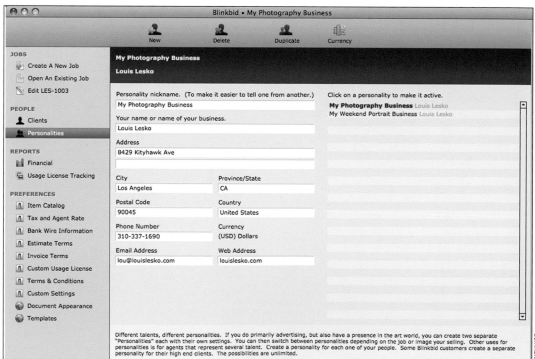

Fred Greaves Photography
5371 Westknoll Lane
San Diego CA 92109

619-994-9207
fred@fredgreaves.com
www.fredgreaves.com

Estimate

Kat Dalager	No:	1000
Cambell Mithun	Date:	4 September, 2007
222 North Ninth Street	Art Buyer:	Kat Dalager
Minneapolis MN 55402	Art Director:	Gretchen Heim
	Agency Client:	Secret client

612-XXX-XXXX office

Job Description
Creative fee for the execution and usage of two ads featuring "real people" photography featuring situations of baking with secret client called "three generations" and "two generations" for one (1) year unlimited exclusive worldwide advertising and promotion in all media except broadcast.

Usage License
Subject to the terms and conditions below, Fred Greaves Photography the creator of the work ("Work") referenced in this document (number 1000) hereby grants to Cambell Mithun defined herein ("Client") an Exclusive license to use 2 images of the Work Worldwide. This license shall be valid for 1 Year from the first publication date and shall cover publication of the Work in the following media only: Unlimited Media. The only credit line to be associated with the Work is "Fred Greaves Photography". Any other use of the Work by the Client shall require a separately negotiated license.

Terms
Estimate is valid for 15 days from the date of issue. Fees and expenses quoted are for the original job description and layouts only, and for the usage specified. Final billing will reflect actual expenses. A purchase order or signed estimate and 50% of the estimate total is due upon booking. All rights not specifically granted in writing, including copyright, remain the exclusive property of Fred Greaves Photography.

Fees

Creative Fee for the execution and usage (two shots of "generations") @	10,000.00
Tech Scouting @ 1,250.00	1,250.00
Fees total:	**11,250.00**

Crew

First Assistant @ 300.00
Food Stylist (a real kid for real kid cookies) @ 250.00
Food Stylists Expenses @ 250.00
Hair and Makeup Stylist @ 650.00
Prop and Wardrobe Stylist (1 prep, 1 shoot, 1 return) @ 650.00/day for 3 days
Social Worker Teacher (on set) @ 350.00

	Crew total:	**3,750.00**
Film, Processing, Prints, Digital		
Digital Capture @ 250.00		250.00
Digital Post Production (Not included in estimate)		
Digital Proofs (DVD of all image Low Res) @ 100.00		100.00
Low Res Contact Sheets (Low Res of all images from shoot) @ 250.00		250.00
	Film, Processing, Prints, Digital total:	**600.00**
Casting		
Casting Fee (1 prep, 1 cast) @ 650.00/day for 2 days		1,300.00
Casting rental location @ 500.00		500.00
Web site set up @ 250.00		250.00
	Casting total:	**2,050.00**
Insurance		
Liability @ 200.00		200.00
	Insurance total:	**200.00**
Location/Studio		
2 Location Fees/Permits (estimating two locations) @ 1,000.00 ea.		2,000.00
Location Scout @ 650.00/day for 2 days		1,300.00
Location Scout Expenses @ 150.00		150.00
	Location/Studio total:	**3,450.00**
Craft Services		
Craft Services @ 500.00		500.00
	Craft Services total:	**500.00**
Wardrobe		
Wardrobe Rental @ 750.00		750.00
	Wardrobe total:	**750.00**
Props		
Prop Rental @ 450.00		450.00
	Props total:	**450.00**
Travel		
Motor Home/Dressing Room @ 650.00/day for 1 day		650.00
	Travel total:	**650.00**
Talent		
1 Adults @ 650.00 ea.		650.00
4 Minors @ 450.00 ea.		1,800.00
1 Usage Bonus (adult talent) @ 1,500.00 ea.		1,500.00
4 Usage Bonus (minors) @ 500.00 ea.		2,000.00
	Talent total:	**5,950.00**
Shipping/Messengers/Transfer		
Fed Ex @ 75.00		75.00
	Shipping/Messengers/Transfer total:	**75.00**
Miscellaneous		
Miscellaneous @ 250.00		250.00
	Miscellaneous total:	**250.00**
	Sub Total	29,925.00
	Talent Fees Billed Direct	-5,950.00
	Sub Total Less Talent Fees	23,975.00
	Total	23,975.00
		43

Signature_____ Date_____

Signature required before job start.

This sample estimate shows the final estimate created for a potential project. A few items to notice: Usage is first, before expenses, and the expenses are spelled out and the terms included. Blinkbid allows you to take your worksheet and transform it into an estimate and then transform your estimate into an invoice.

\- \-

<<

Blinkbid is our favorite program for creating professional, industry-standard estimates and invoices. Blinkbid offers an affordable estimating program that works as a check-off list for line items.

\- \-

Estimate/Invoice (remove one)

Attn: DATE:

JOB TITLE:
ART BUYER:
ART DIRECTOR:
JOB #:
LOCATION:
DATE(S):
Image description

Creative
Creative fee:
Images:
Usage:

Expenses

Digital capture fees	1	@	$0.00	x	1	shots	$0.00
Production crew							
Producer	1	@	$0.00	x	1	days	$0.00
Assistant producer	1	@	$0.00	x	1	days	$0.00
Location scout	1	@	$0.00	x	1	days	$0.00
Lead assistant	1	@	$0.00	x	1	days	$0.00
2nd assistant	1	@	$0.00	x	1	days	$0.00
Grip	1	@	$0.00	x	1	days	$0.00
Prop stylist	1	@	$0.00	x	1	days	$0.00
Assistant prop stylist	1	@	$0.00	x	1	days	$0.00
Wardrobe stylist	1	@	$0.00	x	1	days	$0.00
Assistant wardrobe stylist	1	@	$0.00	x	1	days	$0.00
Food stylist	1	@	$0.00	x	1	days	$0.00
Hair & makeup	1	@	$0.00	x	1	days	$0.00
Talent	1	@	$0.00	x	1	days	$0.00
Locations	1	@	$0.00	x	1	days	$0.00
RV	1	@	$0.00	x	1	days	$0.00
Equipment rental	1	@	$0.00	x	1	days	$0.00
Model maker	1	@	$0.00	x	1	days	$0.00
Props							$0.00
Delivery	1	@	$0.00	x	1	days	$0.00
Wardrobe							$0.00
Catering	1	@	$0.00	x	1	days	$0.00
Craft services	1	@	$0.00	x	1	days	$0.00
Insurance	1	@	$0.00	x	1	days	$0.00
Retouching	1	@	$0.00	x	1	days	$0.00
Mileage	1	@	$0.49	x	1	days	$0.00
Cell	1	@	$0.49	x	1	days	$0.00
Miscellaneous							$0.00
						Total expenses	$0.00
Total fee							**$0.00**

Please make all payments payable to:
Company Name & Address

EXAMPLE TERMS: Upon approval, a 100% advance of final estimated expenses will be due before pre-
production can begin. The balance will be due within 30 days of the final invoice date.

Word/Excel estimates can sometimes look unprofessional as well, but if they are well designed they can work for you. (We provide one on the CD included with this book.) Make sure the estimate and the invoice are the same, line by line, and are aesthetically pleasing.

Consultant Seth Resnick offers pricing assistance. To find out more info, visit: www.D65.com/priceassist.html.

Some photographers like to include a Terms and Conditions section with their estimate. A form that lays out terms and conditions that are standard in the industry is included in the book's CD. See Appendix B for a downloadable file.

Tips for Negotiating

You've submitted your bid, but the client has issues with the pricing you submitted. What do you do?

First, be willing to walk away if your fair demands are not met. Second, bid the job the way it should be produced, rather than trying to make your bid fit an unrealistically low budget.

You can also hire someone to estimate your fees or negotiate on your behalf. Make it absolutely clear to the client with whom they will be negotiating. A negotiator is paid an hourly rate or a flat fee and/or a percentage of the fees if you get the project. In addition to her other roles, co-author Suzanne Sease also works as a negotiator (www.suzannesease.com).

If you have a preference for how you like your estimates to look, an Excel estimate template (a downloadable file is provided on the book's CD; see Appendix B) can be your solution. It gives you more control of how you will show the copy and expense figures.

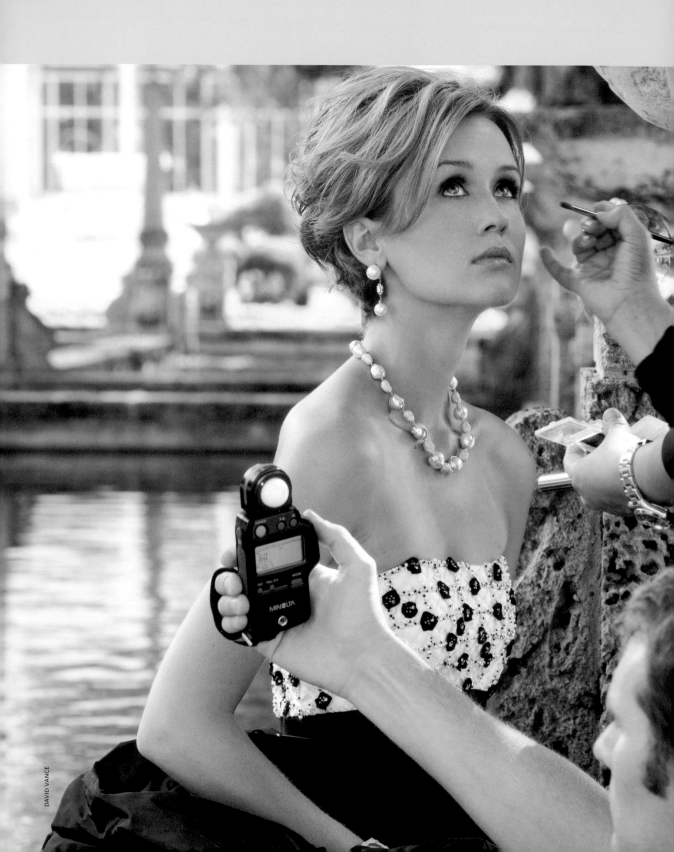

DOING THE JOB

WORST-CASE SCENARIO: YOU GET THE JOB BUT HAVE NO IDEA WHERE TO START. YOU ASK YOUR MOM TO CALL THE ART BUYER AND TELL HER YOU ARE SICK.

WORST-CASE SCENARIO: THE CLIENT WANTS RECEIPTS AND YOU DIDN'T SAVE ALL OF THEM.

WORST-CASE SCENARIO: THE CLIENT IS UNHAPPY WITH THE IMAGES YOU PRODUCED AND DOESN'T WANT TO PAY.

The answer to all of the above: Be prepared for every situation. Photographers often do things at the last minute. You need to work against that tendency. The advice in this chapter—on how to handle business issues before the shoot, on the set, and after the shoot—will help you conduct a smooth, efficient shoot.

Ask the client at the start of the project what they need in order to reimburse you for expenses.

It is the client's responsibility to have a representative (say, the art director or account executive) on the set. Make a Polaroid-like version of each shot (a quick digital print or an image posted in an online gallery for clients to view) and get that person to sign off on it. If the client doesn't like the work but has not sent a representative, you are not obliged to fund a re-shoot. You can agree to re-shoot for no or half the fee, but all expenses must be covered.

What if you need only half of everything we suggest in this chapter? That is the best worst-case scenario of all.

Production Value Is Key

In the days and weeks before the shoot, you will be getting people lined up, assembling the equipment you will need, and generally preparing for the shoot. During this time, foremost in your mind should be the production value you and the crew will strive to deliver—the unique feel or style that the client has hired you to create.

The CD included with this book provides downloadable files for a number of documents that will help you to organize and keep track of the many details that come with producing and successfully completing a shoot. See Appendix B for an image of each form and more about its importance and usefulness:

>> **Approved Job Check-Off List.** Helps you cross all your *t*'s and dot all your *i*'s.

Strong set design, wardrobe, and prop styling support the overall production value of the shot and Christopher Robbins's ability to tell a story.

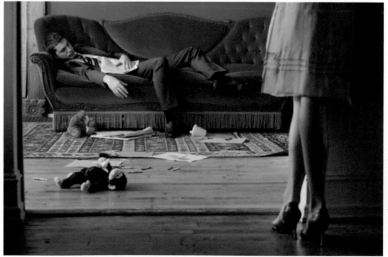

CHRISTOPHER ROBBINS/DIGITAL VISION/GETTY IMAGES

- **Location File.** Organizes your notes about the shooting location.
- **Talent Casting Form.** Records details about the individual models you have cast.
- **Talent Booking Worksheet.** Helps you keep track of the bookings you have made.
- **Wardrobe Check-In Sheet.** Helps you keep track of wardrobe items you've purchased.
- **Wardrobe Disposal Sheet.** A record of wardrobe items you've returned and kept.
- **Prop Check-In Sheet.** Helps you keep track of the props you've purchased.
- **Prop Disposal Sheet.** A record of the props you've returned and kept.

Before the Shoot

It is very important to ask the buyer about the schedule for the shoot. The schedule should be based on the final deadline: the date for the completed images to be delivered to the client, whether a magazine, an ad agency, or a corporate client. If you shoot an image and have to deliver a retouched version, be sure you include that in your schedule.

Once the schedule is set, everyone involved in the shoot should have a copy. It puts everyone "on the same page" as they pace themselves and work toward a common goal.

If the client needs to approve locations, talent, and props, make sure you ask about and settle these issues up front and factor any complications into the schedule. To speed up the approval process, create a Web gallery, an online counterpart to a series of Polaroids that can be accessed online by the client; posting images to the Web gallery allows the clients to review an item and quickly approve it. The Web gallery can also contain and show copies of location files and casting sheets.

When producing a project, large or small, it is important to make sure all team members—from assistants and caterer to talent and stylists—have the contact information for everyone else. Even include the FedEx number to cover shipping costs. (See Appendix B for a downloadable version of this template.)

CALL SHEET

	Name	Number(s)
Agency		
Account executive		
Art director		
Art buyer/producer		
Photographer		
Representative		
Producer		
First assistant		
Second assistant		
Digital technican		
Location scout		
Wardrobe stylist		
Wardrobe assistant		
Prop stylist		
Prop assistant		
Hair & makeup		
Groomer		
Hair stylist		
Makeup artist		
Studio rental		
Car service		
Car rental		
Messenger service		
Caterer		
Equipment rental		
Model		
Model		
Model		
Model		
Model		
FedEx/UPS number		

CALL SHEET/PRODUCTION BOOK

No matter how small or large the project, it is important to make sure everyone has all contact information, including numbers for the client and the entire crew. If you are traveling to a location, include information on flights, hotels, rental cars, caterers, and RV drivers as well. We also highly recommend noting additional information like FedEx numbers, cab service companies, and anything and everything that might benefit you, your crew, and/or the client on the job.

TALENT AND PROPERTY RELEASES

Have releases signed before the shoot. You need this protection if things don't go as planned. Without signed talent and property releases, if something goes wrong you cannot use the images. Some agencies have release forms they like to use. Be sure to ask.

Make sure you have a release signed before the shoot in case something goes wrong and the talent becomes uneasy or upset.

Talent Release

Client _____

Job # _____

Job description _____

Photographer _____

Art director _____

Usage _____

Talent _____

Agent/agency _____

Rate _____

By signing this release, I give [**agency and client**], their agents, representatives, successors, and assigns, the absolute right and permission to use photographs or likenesses of me as well as to use my name for the above stated usage. I also relinquish any rights to final inspection or approval of the work or finished product.

I understand that [**agency**] will be granted full permission to copyright in their name and use, alter, and publish, in whole or in part, such images, and that [**agency and client**] shall solely own the copyright to the reproduced images.

I understand that [**agency**] is not responsible for any personal injury or harm due to my own negligence. I hereby release [**agency**], [**client**], and all persons acting with their permission or authority from any liability which I, my heirs, successors, or assigns may claim.

I understand that all information regarding this project is highly confidential and that I may not disclose any information, no matter how trivial, regarding product, concepts, or any other aspect related to the project.

I am of legal adult age and have every right to contract in my own name the consent to the rights and usage stated above. I have read the above authorization, release, and agreement and am fully aware of all that it states or implies. If talent is a minor, I am signing as a parent or legal guardian with full authorization to act on their behalf.

_____ _____

Print name Date

_____ _____

Signature of talent or parent/legal guardian Social Security #

_____ _____

Address: talent's (if independent) or agency's Talent or agent's phone #

A signed property release guarantees your right to use the location, even in the face of unexpected difficulties. Without the release, those difficulties could leave you without a location or without the right to use the image already captured.

Property Release

Client _____

Job # _____

Job description _____

Photographer_____

Producer _____

Property name _____

Address_____

Phone number_____

Usage: Unlimited advertising and promotional rights for an unlimited period of time.

By signing this release, I give [**agency and client**], their agents, representatives, its agents, representatives, successors, and assigns, the absolute right and permission to take and use photographs of the above named property and to use its name for the usages stated above.

I understand that [**agency**] will be granted full permission to copyright in their name and use, alter, and publish, in whole or in part, such photographs of the property, and that [**agency and client**] shall solely own the copyright to the reproduced images.

I waive any rights to inspect the finished work and/or product or to approve its use.

I hereby release [**agency**], [**client**], [**photographer**], and any person acting with their permission and authority, from any liability due to distortion, alteration, blurring, or positioning that may occur in the process of producing or reproducing the photography.

No further claims will be made by me, my heirs, successors, or assigns.

I hereby warrant that I am of legal age and have every right to contract in my own name the permissions granted above. I have read this authorization release and agreement and am fully aware of its contents and implications.

_____ _____
Print Name Date

Signature

_____ _____
Witness Date

THE CLIENT'S PURCHASE ORDER AND TERMS AND CONDITIONS

When you receive the purchase order (PO) and read through the client's terms and conditions, sign it immediately. Many companies will not use you if you do not agree to their terms and conditions, so you must understand what they are asking for up front.

Many agencies slip an exclusivity clause into their terms and conditions without paying for it up front. This means they own the rights to the image forever and you are unable to sell that image to others once the usage terms have expired.

If you do not want to sign certain clauses on a purchase order, cross them out, but ask the buyer to approve the changes you have made with a signature; otherwise they are not legally valid.

FINANCING THE PRODUCTION OF A JOB

This is a tough part of the business, but you usually have to finance a large portion of any project. Then, once you've completed the project, you need to have all receipts ready to submit with your invoice, which will need to be approved by the client and then finally processed.

If you're going to finance the project yourself, you should have a line of credit with your bank. If you have bad credit, you should not take on large projects that you cannot finance. Instead you should work to get your credit in line first.

If you're unable to finance the project, ask the client for a cash advance. Some agencies will advance up to 100 percent of expenses and even part of your creative fee. You can ask for 50 percent, 75 percent, or even 100 percent of your total estimated expenses. When planning to ask for an advance, consider your best approach. Will you be able to get more by asking for 50 percent of the total job (creative fee and expenses) or, instead, 100 percent of the total estimated expenses?

Ask the agency about their policy on advances and try to negotiate if you need to, but make sure you are fair. You typically will need to send the agency a cash advance invoice in order to get a check. Also ask whether the agency needs to first get the money from the client before

JOB NUMBER	CODE DESCRIPTION	PO NUMBER
A8028	PF PHOTOGRAPHY FEES	P00064819

CLIENT	PRODUCT	P.O. DATE
	PHOTOGRAPHY	03/31/08
		$12,000.00
		P.O. AMOUNT

NOTES:
Color digital photography shot in studio in Chicago over a period of 2 days. Close-up silhouette shots of food items. Colored backgrounds to be created in post-production. Hero package provided by agency.

1) Close up of a fresh pear
2) Short stack of chocolate pieces
3) Close-up of a bunch of grapes
4) Caramel ribbon drip and swirled caramel
5) Hero package shot

PHOTOGRAPHY FEES: $7,000.00
ESTIMATED EXPENSES: $5,000.00
TOTAL ESTIMATE: $12,000.00

USAGE: One year unlimited exclusive worldwide advertising and promotional rights in all media of all images. Effective date of first use. Photographer retains self-promotion rights. Client reserves first option of re-use.

SECOND YEAR OPTION USAGE FEE: Additional $2,000 per ad
THIRD YEAR OPTION USAGE FEE: Additional $1,000 per ad

ESTIMATE INCLUDES: Photography, prep and usage fees; digital capture and processing fees; photo assistant; food stylist & groceries; craft service; rigger for caramel shot; backgrounds & surfaces; equipment rental; misc. supplies; messenger & deliveries; insurance; production coordinator.

This order is subject to all the terms and conditions stated on the reverse or 2nd page of this order. If any terms contained in Supplier's acceptance of this order or in Supplier's invoices are at variance with the terms of this order, the terms of this order shall govern. No oral agreement or other understanding shall in any way modify or change the terms of this order unless agreed to in writing and signed by Agency. No work and/or service in excess of specifications will be accepted as billable material.
Supplier must countersign a copy of this Purchase Order ("PO"), or provide its electronic equivalent. Unless Agency has received a countersigned copy, Supplier will not receive payment. If delivery of work covered by this PO precedes Supplier's signing of this PO, then Supplier's delivery of the work will constitute its unqualified acceptance of this PO. The individual signing on behalf of Supplier represents and warrants that he/she has the authority to bind Supplier to this PO.

Supplier _____

By _____ as agent Date _____ By _____ Date _____

for its Client or any Client named herein or in materials furnished to Supplier in
connection herewith.

| SUPPLIER COPY | Please Sign and return this copy with your invoice. |

TERMS AND CONDITIONS

1. INVOICING INSTRUCTIONS. Instructions must be followed for invoice to be paid. Submit your invoice as soon as possible. Invoices received later than 45 days after completion of work will not be paid, unless a written request for an extension is received within the 45 day period. Include client, product and job number, as indicated on the face of this Purchase Order ("PO"), on your invoice. Show all tax and shipping charges as individual items. Each invoice must be accompanied by a signed and dated copy of this PO. Each PO issued must have a separate invoice. Where models, property locations, stock music, stock photos and/or stock footage are used, a copy of the appropriate release form must be attached. Where delivery is to a location other than Agency's office, Agency will require proof of delivery prior to processing payment.

2. PARTIES. Agency is acting as agent for the Client named on the front of this PO. Supplier, acting as an independent contractor, warrants and represents that it has full power to accept and perform all terms and conditions of this PO.

3. OWNERSHIP/USE. In the event that the materials, including, but not limited to all artwork, photography, illustrations, music, software (including computer programming, source and object code, and HTML formatting) and other materials, services and rights furnished by Supplier hereunder (collectively, the "Work") are copyrightable subject matter, Supplier and Agency hereby agree that for the purposes of this PO the Work shall be a work made for hire and the property of Agency as agent for Client. In the event that any Work which is the subject of this PO is not copyrightable subject matter, or for any reason cannot legally be a work made for hire then, and in such event, Supplier hereby assigns all right, title and interest to said Work to Agency as agent for Client and agrees to execute such documents as may be necessary to evidence such assignment(s). Agency shall have the perpetual right to use the Work (a) in all media as part of Agency's creative reel or portfolio, (b) for educational and editorial purposes and (c) for criticism and commentary purposes (including as part of award shows) whether in digital form or any other form now known or hereafter devised. Agency and Client shall not be obligated to cause the Work to be used, it being understood that Agency's only obligation is to make the payment(s) required under this PO.

4. SUPPLIER'S WARRANTY. Unless otherwise explicitly provided on the front of this PO, Supplier hereby represents and warrants: (a) that no third party has any rights in, to, or arising out of, the Work supplied hereunder; (b) that Supplier has full and exclusive right and power to enter into this agreement; (c) that all models and any other living persons, or the representatives of any deceased persons whose names, voice, signature, photograph or other likenesses are used in the Work, and the owner of any copyrighted material or other objects, properties or rights which are used in the Work, have executed releases allowing use by Agency; (d) that the Work supplied hereunder complies with Agency's specifications and is free from any material defects in design or workmanship; (e) that Supplier shall not permit or authorize use of the Work by anyone in violation of the exclusivity terms, if any, specified in this PO; (f) that Supplier has and shall maintain adequate liability insurance during the Term covering Supplier's indemnity obligations contained herein, and (g) that the Work supplied hereunder complies with and/or has been produced in accordance with all applicable state, federal and municipal laws and regulations. You shall be liable at all times for any materials delivered to you by us and shall return to us, without further demand, all such materials including props.

5. INDEMNITY. Supplier agrees to hold Agency, Client and their respective assigns and licensees, harmless from and against any loss, damage or expense, including court costs and reasonable attorneys' fees, that Agency, Client, and their assigns and licensees may suffer as a result of (a) any breach or alleged breach of the foregoing warranties, (b) claims or actions of any kind or nature resulting from the use in any manner of the Work furnished by Supplier hereunder or (c) Supplier's negligence or willful misconduct.

6. REJECTION AND APPROVAL RIGHTS. All Work covered by this PO shall be subject to Agency's approval. Agency reserves the right to reject and not pay for Work which in Agency's sole discretion is not satisfactory for the purpose for which it was ordered or which was not delivered in accordance with the specifications of this PO, including timely delivery, which is of the essence. Delivery of the Work and/or payment therefore does not constitute an acceptance. Defects are not waived by Agency's failure to notify Supplier. The return of such defective Work shall not relieve Supplier from liability for failure to ship satisfactory Work under this PO. Agency shall not be responsible for any costs associated with shipping rejected Work back to Supplier or for any risk of loss to such Work while in transit.

7. CANCELLATION. Unless otherwise provided in a separate Contract, this PO may be canceled by Agency at any time prior to its acceptance of the Work covered by this PO, upon written notice to Supplier. In such event, unless such termination is based on Supplier's breach, Agency will pay Supplier, in lieu of the price specified on the front of this PO, the direct costs theretofore incurred by Supplier prior to such cancellation, provided, however, that the total amount of such costs shall not exceed the price specified on the face of this PO.

8. CONFIDENTIALITY. Supplier covenants and agrees that it and its employees and agents will not disseminate, reveal or otherwise make available to others, or use for its own purposes, any information of a proprietary or confidential nature concerning Agency or Client, learned by Supplier or its employees or agents in the course of fulfilling this PO regarding, but not limited to, trade secrets and confidential information, advertising materials, ideas, plans, techniques, accounts, business, prices, customers, products and methods of operation.

This is a typical client purchase order (PO) and statement of terms and conditions (T&C). Always ask for a PO before moving forward on a project. Read all agency POs very carefully. Some agencies use POs just for their photography assignments, while others use them for everything from copier paper to computers to your services.

issuing you a check, as this may slow things down. You may want the agency or client to wire the money into your bank account.

Ask nicely for the advance. If you don't get it, be very clear that you will need to be paid immediately following the shoot. Whatever you do, don't threaten not to shoot because you have not received an advance—if you do, you will never work for that agency again and your reputation will be out the door. People do talk and word gets around.

If you are awarded 100 percent of the estimated expenses, remember that on your final invoice you must deduct that amount from the total amount due. If you asked for $50,000 up front but your expenses totaled $45,000 and your fees are $10,000, your final bill will be for $5,000—the remaining amount due.

INSURANCE

Make sure you have proper insurance before stepping onto the set. While many agencies will provide insurance, this is still not the norm. We recommend having $1 million in coverage. You can research your best insurance options through an organization like Advertising Photographers of America (APA) or American Society of Media Photographers (ASMP).

On the Set

Working on the set is your time to shine as an artist. How you handle yourself, speak to your crew, communicate to your client, capture the image—all will contribute to defining your moment of truth. Always strive to create and run a set that clients want to return to.

WHAT HAPPENS WHEN SOMETHING GOES WRONG?

First, stay calm, and then contact the person who hired you—usually the person who issued the purchase order. Make them aware of what has happened, and don't make it their fault or problem. Give them the scenario and how you think it should be resolved. Let them know of any additional cost. Have a change order or budget overage form with you on the set and have whoever is responsible for the cost change sign it. (The CD packaged with this book provides one.)

This form must be on the set of every shoot you do. It is the only way to cover yourself if someone who has hired you asks about something that was billed but not estimated. There should be someone on the set who is sent as a representative of the client and is responsible for approving this additional cost. (The CD packaged with this book provides a downloadable template.)

Budget Overages

Pre-pro/After estimate approval/On-set

Job # _____

Client _____

Project _____

Photographer _____

Producer _____

Overage amount $ _____

Overage item(s) _____

Reason _____

Approval signature _____

Printed name _____

Title _____

Date _____

By signing this overage report, the client agrees to pay the overage incurred subsequent to approval of the estimate provided by the photographer and/or agent and/or production company. This overrides any approval from a third-party cost consultant.

It's important to make all this happen without making too much of an issue in front of either the agency or the client. Doing all of this is usually the role of a producer. If there is no producer, it's the role of the photographer.

DIGITAL FILE BACKUP

Be prepared to have two hard drives on the set and to back up the entire day's shoot on multiple hard drives. There is nothing worse than spending $20,000 to $100,000 of your client's money and then losing the work. Do not let this happen to you.

After the Shoot

You have completed the shoot, and now you have more work to do: gathering receipts from everyone involved on the job, post-production processing, delivering the final artwork, doing your final invoicing, and sending a thank-you note to the art director and/or art buyer on the job.

You want completing the final product and delivering it to be quick and smooth. Giving the client a superior final product—on time and within the budget—will "seal the deal" for you. Your client will walk away with a great overall experience and will be likely to call you again in the future.

HOW TO KEEP RECEIPTS FOR FINAL BILLING

Use an adding machine with a printable paper tape, or use the "show tape" option on your computer's calculator and print out the calculations. Staple or tape receipts (originals or copies; be sure to ask what

When sending in your invoice, make sure to show original receipts. Tape the receipts per category (food, props, wardrobe, etc.) and in chronological order. Show an adding machine tape of the receipts per page, and attach the tape to the top right-hand corner of each page. At the beginning of each category, provide either a cover sheet of the items that follow or an adding machine tape of just the totals for the pages.

the agency or company requires), organized into categories, on sheets of paper.

In each category for which you have receipts (props, wardrobe, travel, etc.), add the machine tape totals for each page and put this figure in an Excel chart to add up for the total for that category.

Calculate the receipts per page with the adding machine tape or computer printout at the top, then create a cover sheet for each category that shows the dollar total of the tallied amounts from the sheets that follow.

SALES AND INCOME TAXES

Before the digital era, an entire project was subject to a sales tax when a tangible item passed from the photographer to the client, but in the digital world, the tax laws have changed.

If the client receives the files electronically, the project may not be taxed, but putting the images on an external drive or disk (which photographers do in order to be able to bill for "digital processing fees") makes it a tangible item even though the images are digital. Check with your accountant.

Also check with your accountant about your income tax situation. For example, if you don't live in California but do a majority of your work there, you may be required to pay California income tax.

THE FINAL INVOICE

Many agencies pay 45 days from the date of the invoice. So it's best to date your invoice using the day of your shoot or one day after.

Your final invoice must look like the estimate and list line items in the same order. All expense receipts should be presented, by category, in the same order that the categories appear on the invoice and in the dated order that appears on the receipt, from the beginning to the end of a project.

If a receipt is not clear, add a handwritten note to provide an explanation. Invoices must balance out to the penny, or most accounting departments will send them back to be revised.

When the entire invoice and all receipts are in order and add up to the penny, send the invoice to the client. Keep one complete set of expense

receipts for your records and send the original receipts in a binder or folder to the client, along with two copies of the final invoice (which you can stick in the back of the binder or folder).

See page 140 and Appendix B for an Estimate/Invoice form. You can use this form to submit your estimate for a job (use the "Estimate" part of the heading), and then submit your final bill using the same form (this time use the "Invoice" part of the heading).

THE WRAP PARTY: WHO PAYS?

A wrap party usually means going out to a restaurant or bar and celebrating. It could cost anywhere from a hundred or two to a couple thousand dollars, depending on how many people are involved and what they drink and eat.

It used to be that the client always paid for the wrap party, and that is what we tend to assume, but there are sometimes situations where people are not sure. Many client representatives are very young and not familiar with who should pay.

If you invite a client to a wrap party, you should be prepared to pay. However, if they offer to pay, do not argue. Many photographers pay and bill the client afterward. This is your choice.

Amanda's opinion is that it's tacky to offer to pay and to then bill the client back without asking up front. However, she feels it's also tacky for a client to assume a photographer has the money to pick up the tab. She recommends asking up front. Suzanne's opinion is that the client pays, as it is part of craft services or per diem. Either way, do your best to handle this issue with grace.

GETTING PAID

If you need to call the agency in order to find out where your payment is, ask them to check if the accounts payable department has the invoice posted, which needs to happen before the invoice can be paid.

Once your invoice is posted, it will be scheduled to be paid on a certain date, and you can ask what that date is for your invoice. It's reasonable to expect your invoice to be paid within 45 days of the invoice date.

06

KEEP MARKETING YOURSELF

WORST-CASE SCENARIO: YOU ARE WORKING. YOU HAVE SEVERAL CLIENTS BUT WOULD LIKE TO BE EVEN BUSIER. YOU SAY TO YOURSELF, "WHEN I AM BUSY I DON'T HAVE TIME TO MARKET. THERE ARE TIMES WHEN I AM SLOW AND HAVE TIME ON MY HANDS, AND THAT'S WHEN I MARKET."

WORST-CASE SCENARIO: YOU HAVE A FEW CLIENTS BUT NOT ENOUGH WORK TO FUND A FULL-OUT CAMPAIGN OF PRINT PROMOTIONS.

The way around the "photographer's cliché" in the first scenario is to plan your marketing in advance. Create and budget for a yearly marketing calendar to keep your name and style in front of buyers—those who already know you and those who should.

Get a few images ready for e-mail blasts. Also print up several mailers that you'll send to your dream clients—cards for sure and perhaps also larger printed pieces—and arrange for a fulfillment house like Agency Access to ship them on the dates you specify.

If your budget is limited, concentrate on e-promotions. Many buyers prefer seeing your work in a paperless way.

Keep Shooting, Promoting, and Making Appointments

Ask yourself: If Coca-Cola stopped marketing for two months, do you think they would see a drop in sales? You should think of yourself the same way.

Consider using 5 to 10 percent of your previous year's earnings for marketing. Once you have been marketing for a year, review that period and see what worked and didn't work, and make revised plans for the coming year based on the previous year's results. If you are just starting out, let your budget dictate what you can afford to do.

Approach a campaign with the knowledge of who you are marketing to—and then jump in. You can find out what works only if you actually

Seiji, a photographer from Hawaii, used creative elements to highlight his work in his e-promo while making the image large and bold. This e-promo captured the attention of an upscale department store chain.

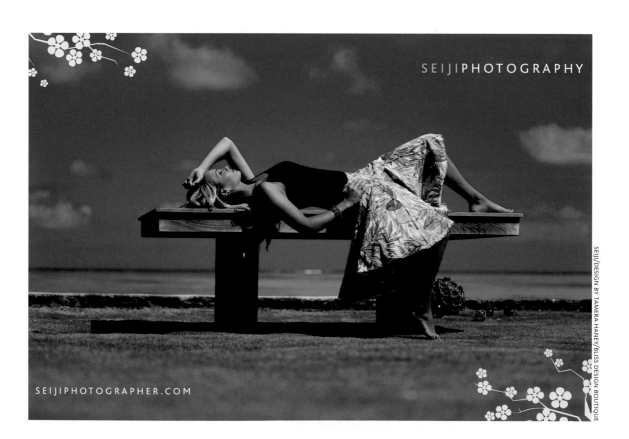

JEFFREYLAMONT**BROWN** PHOTOGRAPHY
JEFFREY LAMONT BROWN : JB@JEFFREYBROWN.COM / 619.227.2701
ADAM RENFREE : ADAM@JEFFREYBROWN.COM / 858.883.1000

click anywhere to go to the website

JEFFREYLAMONT**BROWN** PHOTOGRAPHY
JEFFREY LAMONT BROWN : JB@JEFFREYBROWN.COM / 619.227.2701
ADAM RENFREE : ADAM@JEFFREYBROWN.COM / 858.883.1000

click anywhere to go to the website

Jeffrey Lamont Brown is a pioneer in the e-marketing arena. He has delivered hundreds of e-promos in a consistent format that shows his images very large and with the type always in the same place. Because he has been doing this for so long, and because he delivers images of compelling visual interest and consistently high quality, thousands of people open his e-promos as soon as they arrive, and his click-through rate is very high.

- -

do it. Of course, that doesn't mean trying everything at once. Keep track of the varying degrees of success you've had with different types of promotion. And once you start marketing, plan to market for the rest of your career.

Remember that you are promoting your work over the long term; if you stop after a few e-promos, you will not have the impact you desire, even if you start up again down the road. As photographer Jeffrey Lamont Brown says, "Art buyers consistently tell us that there are two things that make our e-promos so successful. Number one is image quality: We work really hard to make sure each e-promo is special, an image that inspires. Number two—consistency—is also key."

Continue to push yourself. You may be known for a certain style, but make sure you continue to develop your work and let people know not only who you are but who you have become. If you stay within your "special style," you will be yesterday's favorite shooter rather than someone who continues to shoot and evolve.

It is always a great idea to contribute to a non-controversial charity and send a card to all the people on your list.

Set yourself a goal for person-to-person meetings. Try to land a brief meeting with a potential new client at least once a month. Getting in front of people is the next best thing to actually landing a job. Meetings allow people to meet the person behind the images. Potential clients remember meeting photographers and reviewing their books.

Hold on to Your Existing Clients

Once you have clients for whom you've done at least one job, be sure to add them to your personal database, and use your mass marketing as a way to remind them that you are still around and available.

Send holiday gifts. To be safe, be holiday-generic ("Happy Holidays" or "Happy New Year"). Be sure not to send inappropriate gifts to clients you do not know well. Gifts that are widely liked include gift cards, prints, and electronic items.

You can also donate to a charity in your client's name. Save money by donating several hundred dollars to a worthy charity and sending a donation card to hundreds of people. Give to a worthwhile cause that really needs the money. Of course, don't make your contribution to a religious or political party as that could offend some clients. Be neutral.

Blogging and the Internet

Everyone's doing it, so why aren't you? By the time you read this, blogging might still be the "in" thing, but maybe not.

If you are not into blogging, the more general point is that the Internet is continually creating new ways for you to feature yourself. First and foremost, there is your website. Then there are visual galleries and search engines for keeping up with the competition and investigating

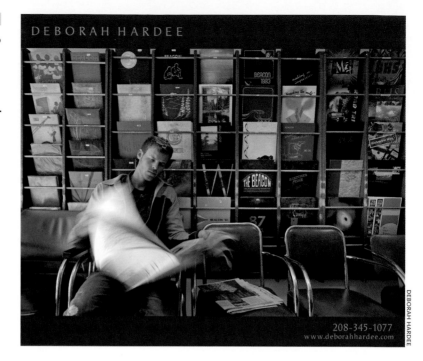

When you send out an e-promo, send it to reps as well. When Deborah Hardee sends this to reps, she always gets requests to see her portfolio.

DEBORAH HARDEE

208-345-1077
www.deborahhardee.com

DEBORAH HARDEE

potential clients. Think about how you can use the Internet to further expose yourself to the public and to reach your target market.

Representation

A good rep (or agent) is someone who believes in your work, shows your work, and markets your work. Once a buyer is interested in your work, a good rep is also someone who knows how to negotiate a deal and get you a good fee. Some reps are solely negotiators, while others provide more marketing and production help. Ask about a potential rep's specialization up front.

While a rep is someone who markets your work for you, a consultant is someone who helps you put together the work to market. They are not the same and a photographer should not expect one to do the work of the other.

When a rep is interviewing you, you should let him know that you are interviewing him as well. You want someone who is going to best represent you.

Ask a potential rep what her rates are and ask to see some examples of estimates she has submitted in bidding on jobs. Most reps charge between 20 and 30 percent of the creative fees you earn.

Ask to speak to photographers who have been or are currently represented by an agent you are interested in, and contact them. Contact their current photographers, art buyers, or other people in the industry for feedback on them. Some reps have been blacklisted from agencies, so be sure to check out their reputations.

>> Question

How much should someone who seriously wants to market themselves estimate in their budget?

>> Answer

On average, $40,000 to $50,000 per year, but it depends on what they can afford. They need half a dozen books. They need to participate in some kind of mass promotion—Le Book, Workbook, Archive ads, etc. They need to have an updated website and be able to send e-mail blast promotions. We have personally scaled back on direct mail, but if someone wants to do a cool, bang-up piece, then go for it. The truth is that most buyers toss that stuff when they look at their mail (once a month!).

—GREGG LHOTSKY,
BERNSTEIN & ANDRIULLI, NEW YORK

How important is having a rep?

It depends on how good a businessperson the photographer is. The rep can respond to agency needs in a much quicker manner than a photographer off in a remote location with no cell phone or Internet. Every production has issues, problems, nightmares, etc. It can be a lot for a photographer to manage while trying to keep the creative issues forefront in their minds, so it helps to have someone dedicated to manage those situations in the best way possible.

—JESSICA HOFFMAN,
SENIOR INTEGRATED ART PRODUCER,
CRISPIN PORTER + BOGUSKY, BOULDER

A knowledgeable rep is indispensable. When they understand the numbers that are being submitted and how the production works, it makes everyone's life much simpler. If they are only there to field phone calls, then it's nonproductive for everyone.

—ROSIE HENDERSON,
SENIOR ART PRODUCER,
BEST BUY, MINNEAPOLIS

It doesn't matter to me one way or the other. What does happen sometimes is "New York snobbery." Some art directors think that the only good shooters are in NYC and have reps.

—KAT DALAGER,
SENIOR ART PRODUCER,
CAMPBELL-MITHUN, MINNEAPOLIS

Most reps will want a portion of your "house" accounts (those wonderful clients who keep coming back). You'll need to decide if having representation is worth that much to you. You can try to negotiate to keep house accounts out of the deal, but many reps will not sign you without having your house accounts as part of the deal.

Some reps do estimating and billing for you, while others do not. Make sure from the get-go that you are clear on what a rep is going to do for you. Signing with a rep is a business transaction that you must take very seriously.

Finding an artist's representative is not an easy task. Reps (or agents) are looking for one of two things: hot, fresh, new talent that is undiscovered or established photographers who bill enough for the rep to make money. What happens if you are neither? Here are a couple of suggestions.

USE YOUR PROMOTIONS TO HELP YOU SIGN WITH A REP

When you send your regular marketing materials out to potential clients, consider adding artist's reps to your database. Many artists have successfully used e-promotion to introduce themselves to reps who have called in their books.

You can find some of the best reps on workbook.com. Check out the reps' websites in order to target those who are likely to appreciate your style and those whose talent pool you sincerely respect.

When Martin Thiel sent out this mailer to buyers and to reps, he got two calls the first day it hit—one from a very large ad agency and one from a great national rep. The rep, who signed him, said, "If you do a great piece like this, then I know you are good."

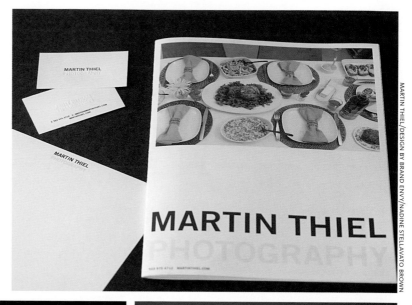

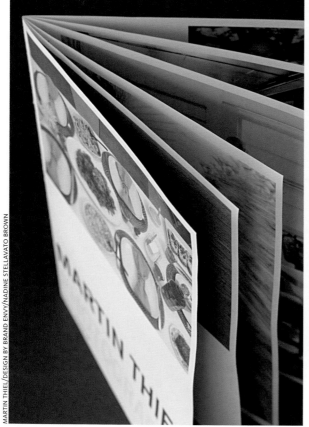

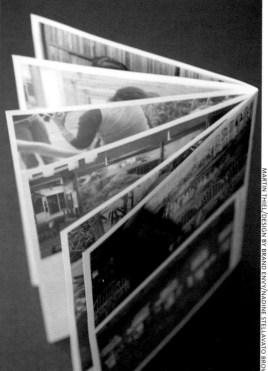

WORKING WITH AND PARTING FROM A REP

Even if you land a rep, most of the marketing, mailing, and shipping of portfolios are your responsibility. But that's okay. You definitely should not sit back and rest if you get a rep. Work collaboratively with him or her, and always be proactive.

A relationship with a rep is like a marriage. All unions, including this one, can end in one of three ways. It can end on good terms when you both have made lots of money and you are ready to retire. The two of you can decide to happily go in different directions. And of course the relationship can end on bad terms. Be prepared for all of these three possibilities.

Parting from a rep can cost you a lot of money. Make sure you review the severance section of your contract with your rep. There are many different types of clauses. For example, some reps base the severance fee on a percentage of what you brought in the year before, and some on the years of service they have provided; some even set a dollar amount for a certain time period of representation.

> ### › HIRE YOUR OWN REP

If you can afford it, hire your own rep. Pay him or her a flat salary for a few months and then move to commission after that. There are a lot of young, fresh marketing students coming out of school that you can train to be your marketer. If you don't have the income, start with an intern and see how he or she produces. Provide an incentive, and if you and your intern get along, then you may have just found yourself a rep.

What do you look for in talent in order to sign them?

- A photographer who is actively working, particularly in advertising.

- Someone who demonstrates a strong point of view with a body of work.

- A person who understands the photographer-representative relationship.

- Someone who has good communication skills and is able to serve as a problem-solver for clients.

—DOUG TRUPPE,
INTERNATIONAL AGENT, NEW YORK

Obviously someone who is talented. But increasingly more important is someone with some business sense. We're partners, so I want someone who is going to give 100 percent of their 50 percent. It's a dog-eat-dog world out there, and the early bird gets the worm! Seriously, fifty or more photographers are considered for any given project. I need to be confident that, if my talent's work makes it to the bidding round, we can work the numbers so that we look like we know what we are doing and be able to do it. And do it with a smile.

—GREGG LHOTSKY,
BERNSTEIN & ANDRIULLI, NEW YORK

What is the biggest change you have seen in the market in the past two years?

Smaller budgets for more usage.

—DOUG TRUPPE,
INTERNATIONAL AGENT, NEW YORK

Folks want things as quickly as possible and don't care where it comes from. From looking at images that reflect their layouts exactly via e-mail, to getting estimates in ASAP with far-reaching usage terms, to having the best bid, I spend a lot of time educating buyers about use, about why a motor home is in my estimate, and what catering is. Perhaps I've been doing it too long and the buyers are getting younger, but it seems more and more that the person in the position of hiring talent knows less and less about hiring talent.

—GREGG LHOTSKY,
BERNSTEIN & ANDRIULLI, NEW YORK

THE AMERICAN SOUTHWEST
LAND OF HARD WON DREAMS

BRUCE DALE ONE MAN SHOW NOV 8, 2003 - JAN 11, 2004

TG
PA TAMPA GALLERY OF PHOTOGRAPHIC ARTS

07

STOCK PHOTOGRAPHY AND CREATIVE OUTLETS

--

WORST-CASE SCENARIO: YOU ARE HAVING SUCCESS WITH COMMERCIAL CLIENTS, BUT YOU MISS DOING WORK THAT PUSHES AND STIMULATES YOUR CREATIVITY.

WORST-CASE SCENARIO: YOU ARE PROUD OF YOUR STYLE AND SHOOT IN A WAY THAT YOU THINK PEOPLE WILL LOVE, AND YOU'D LIKE TO BROADEN YOUR EXPOSURE.

WORST-CASE SCENARIO: YOU ARE SO BUSY OR WEALTHY YOU DON'T KNOW WHAT TO DO WITH YOURSELF.

Don't ignore other sources for getting your work out there. Stock photography can be a great way to do that. Also, check out industry organizations and sources for news and information.

Working as a commercial photographer does not mean that you cannot continue to grow as an artist. In fact, a photographer whose style is continually evolving is more likely to have success year after year than one whose work remains the same.

We wish the last-mentioned scenario on all of you reading this and hope that this book has helped.

Stock Photography

This section was written by Ellen Boughn (www.ellenboughn.com). Ellen, an amazing stock consultant, explains how distribution of images as stock photos might benefit your business.

According to the Picture Archive Council of America (PACA) there are currently more than 100 member stock agencies and archives in the United States and more than 50 international members. The big three—Getty Images, Corbis, and Jupiter—get the most press, but many photographers find that they are equally or more successful in some of the second-tier but still large companies, like Masterfile (www.master-file.com), that are primarily known as "rights managed" stock agencies.

Only rarely does a stock house purchase images for their collection. Instead, the images are "represented" or "distributed." The photographer is paid only when an image is licensed.

If a photographer is hired by a stock house to shoot an original image for their collection, he or she is either paid a one-time flat fee (a buy-out) or the stock house pays for production and pays the photographer once the production fees have been earned.

Depending upon the nature of the work, niche agencies with specialized collections, such as Science Faction (www.sciencefaction.com), Aurora (www.auroraphotos.com), and Alaska Stock (www.alaskastock.com) might be the best choice. Visit www.pacaoffice.org for a full listing of agencies and begin your research.

TRADITIONAL VS. CROWD SOURCING

The microstock or crowd-sourcing movement enables skilled amateurs, semi-pro, and professional photographers to prepare large numbers of images using today's easily available, high-quality digital cameras to reach the huge audiences on the Web that want low-cost images for websites, blogs, and other commercial uses.

The images license for very low fees—from less than $1 for subscription images to $1 and up. The microstock company Dreamstime (www.dreamstime.com), for example, licenses images to an expanding audience of users that is exploding laterally as the need for images for personal blogs and localized websites expands. The users of microstock stock images also include some of the traditional users of stock photography, such as ad agencies, corporate art departments, and magazines.

Some people are against the microstock companies since they feel that the fees or the commissions are too low. In reality, several top stock photographers who have joined the microstock movement indicate that microstock revenue is closing in on the level of income they receive from more traditional stock distributors. It's a question of volume: Does an image that sells for $300 and is rarely licensed make as much as an image that sells for $1 and is downloaded hundreds of times?

The traditional and crowd-sourcing distribution models for stock photography can be thought of in the same way that Chris Anderson, the author of *The Long Tail*, compares blockbuster hits at the multiplex theater to the NetFlix distribution model. One grosses a lot at once, while the other grosses a lot over time and services a wider group of people. One is not better than the other—the two are different. Which way to go is your choice. In most cases, it's a good idea to participate in all levels of stock licensing: rights managed, royalty free, and microstock.

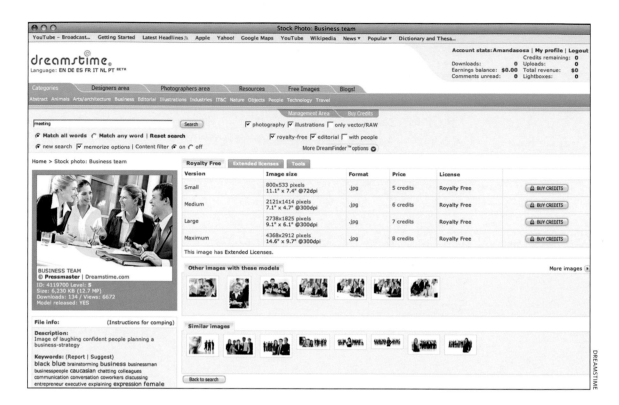

Dreamstime is a peer-to-peer, community-based "microstock" photo site that grows at the rate of 25,000 images a week and has hundreds of thousands of users. Their site (www.dreamstime.com) is one of the most visited stock photo sites among all stock photo companies, including the traditional players such as Getty Images and Corbis. Dreamstime pays the highest commission to its contributors of all the companies in the space according to a recent survey by *PDN*.

The key is having a sense of what type of work belongs with which type of company. Some photographers find that their work is appropriate in some or all of the different kinds of agencies.

Some companies pay only 20 or 30 percent in royalties. Others that are sensitive to the needs of their community pay much more. Dreamstime royalties average 50 to 60 percent to the photographer.

WHAT WORK TO SUBMIT AND HOW TO SUBMIT IT

Once you have targeted the company or companies you feel will be best for your work, you need to take the next appropriate step for each type of agency.

For the large general agencies, it helps if you have won awards such as appearing in the *Communication Arts (CA) Photography Annual* or if you have been lucky (and good) enough to place in the *PDN* "30 under 30" annual selection. These are places where big agencies scout for new players. Enter often. You may win more than just a place in a magazine.

For the niche companies, research their collections and put together a presentation on DVD. Target images that will knock their socks off. Send them images similar to what they already offer, especially images that fall into their genres that are light on offerings.

The barriers to entry for the microstock companies are low: Follow their submission rules and, bingo, you are on the site. The marketplace, rather than an editor, decides your fate.

INDUSTRY RESOURCES

The stock photo industry has been around in various forms for decades, and many resources and organizations have developed to provide information, education, and assistance to stock photographers.

❯ *Legal*
Several U.S. lawyers specialize in common legal issues facing photographers. Nancy E. Wolff, counsel for the Picture Archive Council of America, is well versed in dealing with photography issues, especially as they relate to stock photography licensing and copyright. You can contact her at nwolff@cdas.com.

❯ *Organizations*
There are four main trade or professional organizations that can be of value to stock photographers.

>> Advertising Photographers of America (www.apanational.com). Membership in APA gives an advertising photographer a network of support as well as access to documents related to model and property releases and other stock issues.

>> Stock Artists Alliance (www.stockartistsalliance.org). SAA is the one organization that every stock photographer should join. Its sole mission is to support the business of stock photographers worldwide. It is the only trade association focused exclusively on stock photography issues.

>> Picture Archive Council of America (www.pacaoffice.org). This is the trade organization for stock distribution companies. A list of members is available to anyone. The companies represented are generally considered to be respected members of the U.S. stock photo industry. PACA has a dispute resolution service.

>> American Society of Media Photographers (www.asmp.org). The oldest of the professional photography organizations. ASMP provides business publications and education to members regarding stock photography and other key photography business issues.

> *News and Information*

The four blogs listed below can be helpful to photographers who work with photography stock houses.

> **FIND A PLACE FOR YOUR IMAGES**

My grandmother had an expression: "There is lid for every pot." In photography the same applies: There is a place in the stock photo distribution business for every quality image. The key is finding it.

—ELLEN BOUGHN,
STOCK CONSULTANT

>> The weekly blog www.dreamstime.com/stock-photography_blog covers subjects, styles, and trends to help photographers plan images to shoot that will be successful as stock photography.

>> The occasional blog www.abouttheimage.com deals exclusively with business issues in stock photography.

>> On www.stockphototalk.com, a blogger based in Germany writes "insider" stories about stock photography and publishes all press releases related to the stock industry.

>> To discuss all aspects of stock photography with working photographers, go to http://tech.groups.yahoo.com/group/selling_stock_ photography/.

Continue to Be Creative

You are an artist and you have to keep those juices flowing. Yes, we all want our pockets to be fed, but at the end of the day the best way to do that is to feed your creative soul first.

Marc Yankus is a perfect example of a photographer who both does commercial work and creates fine art photographs. His unique style, which bridges the gap between commercial and fine art, can be used in both arenas. Shown here is Marc's website: www.marcyankus.com.

LEARN OR TRY SOMETHING NEW

To be a really good artist and to continuously improve on your skill, you have to try new things. Take a class online or at your local college. Go to resources like craigslist.org and do other research to find groups in your area. Websites like www.lynda.com offer lots of opportunities to learn.

BRUCE DALE

Bruce Dale, a well-known *National Geographic* photographer, uses his spare time to show his personal fine artwork. Diversify yourself and show your work in galleries. Remember, you are an artist, and it is essential that you remain an artist.

BRUCE DALE

FINE ART

Being a photographer means that you are an artist first. However, the reality is that some commercial jobs do not allow you to completely express yourself. So when you are on your own time, shoot above and beyond your safety zone. Look into the possibility of mounting shows or gallery exhibits or delving into other personal projects that will stretch you creatively.

Creative personnel at clients and agencies love to see your other skills and work that goes beyond your traditional style. Of course, you should position this work in the personal section of your website, so it is not confused with your professional photographic style or existing portfolio.

WALTER LOCKWOOD

WALTER LOCKWOOD

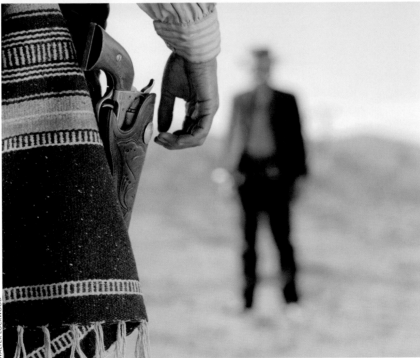

This series of images, "Sukiyaki Western," represents the simulated reality through which we experience the American West. Walter Lockwood was inspired by the iconic film images of the Wild West created by director Sergio Leone. Using Asian actors, Lockwood set up this re-creation to illustrate that our view of the American West is rooted in simulation and thus that our perceived realities are being created, re-created, accessed, re-accessed, confirmed, and re-confirmed constantly and automatically. In this way, cultures blend and dissolve just as our experience of the world around us is constantly shifting through our real perceptions that are based upon simulations.

Mary Virginia Swanson is a great fine art consultant. She knows all the ins and outs of the fine art world and how to market in that arena. Swanson maintains a popular blog on marketing opportunities for photographers: www.marketingphotos.wordpress.com.

Here is an excerpt from Swanson's self-published book The Business of Photography: Principles and Practices, *available on her website (www.mvswanson.com).*

Recognition for your creative efforts is gratifying and profitable. The path to bring your work to the attention of industry professionals who can help your career is difficult to navigate, and like creating photographs, an investment of your time and money. Gallery owners, museum curators, photo editors, collectors and other professionals will all confirm that ultimately their decisions to buy or commission you to create new work is based on the quality of the photographs. Without presenting your work to industry professionals and collectors, your career will not move forward.

Three paths to building relationships in the fine art community:

ENTERING JURIED EXHIBITIONS

Submitting your work to juried exhibitions will enable you to bring your personal work to industry professionals while learning to edit and write about your images, and transport your fine art photographs with minimal risk. It is important to research which competitions to enter, as there are many options; some will charge fees per image submitted; others require a flat fee for your entries. You should thoroughly research which jurors or exhibition theme most closely corresponds with your work; for example, a juror who owns a gallery known for classic black and white landscapes is less likely to respond to experimental digital photography than a curator at a museum known for exploring applications of new technologies within contemporary art.

ATTEND PORTFOLIO REVIEW EVENTS

Portfolio review events are an effective and efficient opportunity to personally introduce yourself and your work to appropriate industry professionals: gallery owners, curators, private collectors, magazine editors, fine art publishers and corporate art consultants, among others will be in attendance. Portfolio review events offer a venue to establish relationships with those who can move your career forward, as well as the opportunity to interact with your peers. Attending portfolio review events has strong potential to return tangible benefits if your work is strong, you do your homework and connect with the right people, and you follow up with new contacts in a prompt, professional manner. There are specific actions to maximize these opportunities and investment of resources over the full arc of your career.

ATTEND PHOTOGRAPHY FESTIVALS AND ART FAIRS

In addition to attending the prominent festivals and art fairs in the US, visiting those happening around the world is of great value to those who are serious about a career that stretches beyond our borders. These gatherings offer a valuable window to market trends and to those cultures most likely to respond to your work prior to investing in promoting your work abroad.

Lastly, it is important that you thoroughly understand the audience you are trying to reach, and "speak" to their needs in their market segment. The information concerning you and your work that will be important to a collector is quite different than what a photography editor would wish to know. Do your homework as you bring your work to new markets!

What happens if your worst-case scenario is not in this book?

Do you . . .

 Call your shrink?
 Call your mom?
 Cry in a corner until you get the answer?

No. You write down what the problem is and take a few minutes to consider who you can talk with about it. Our hope is that you will be able to use the resources provided here to help solve your problem.

A bottom-line piece of advice for people facing a worst-case scenario: Never, ever feel pressured to give anyone an answer immediately. Take your time to work out the issues, use common sense and the advice given in this book, and conduct yourself professionally and with confidence.

This book is intended to show photographers that everyone encounters every-day challenges, but that there are many solutions to any given problem and many creative resources out there to help.

We hope you will benefit from this guide and the resources it presents, and that they will make your life much easier and more enjoyable. The information and points of view included in this book reflect our personal experience and the advice we have gotten from hundreds of industry contacts.

Create! Enjoy your life and your career! But remember: Your personal life comes first. If you are fulfilled in your personal life, that fulfillment will carry over to your professional life.

TERMS TO KNOW AND UNDERSTAND:

USAGE STATEMENT GUIDELINES FOR PHOTOGRAPHERS

BY KAT DALAGER, SENIOR ART PRODUCER,

CAMPBELL-MITHUN, MINNEAPOLIS

With the current U.S. copyright laws as they are applied now, artists own all rights to their created images and sell/transfer rights to agencies and their clients. All questionable negotiations historically have defaulted in favor of the artist. Technically, even minor modification of the art requires your permission. You are *renting out*, not selling an image, unless explicitly stated otherwise on the contract.

Generally, think of usage costs as reflecting the amount of exposure a particular image may receive. The more exposure, the higher the price. Exact terminology may differ, but the semantics remain the same if all of the information is included in each negotiation. You can phrase it any way you want, but be clear about the *intent* by including information from all categories outlined below.

Also, consider the *value* of the image to you: A shot of a Coke can on a white background may have a more limited value since it features a licensed product and requires less of your creative input. How unique is the shot? How much of the creation of the shot was your concept?

Talent usage is similar, but there are differences in how each medium is priced: Talent usage (the right to use a model's image in an advertisement or promotional material; you cannot use someone's face if it is recognizable without their written permission) tends to be much more specific. Again, it is based on exposure. If you are responsible for talent usage, be sure the usage matches what you've been contracted to cover.

European terminology differs from U.S. terminology, particularly in the "Print" category. In Europe, "print" includes anything that is not broadcast.

Although category headings may vary (for example, one may use "time period" and another "length of time"), usage is defined by the following:

Time Period or Length of Time

This is the length of time an image or images will be used: one time, one year, two years, etc. To avoid confusion, it is best to specify "from date of first use" or "from shoot date"

when negotiating a contract for an image. Standard use generally defaults to one-year use (from shoot date) in a specific medium unless terms are otherwise negotiated.

Rights/Quantity

This is the number of times *within the time period* that the image will be used.

LIMITED

You would use "limited" to specify, for example, a limited number of times, such as "2 insertions" or "a run of 5,000" within the time period sold. By the time you reach multiple insertions in publications such as *People* or *USA Today,* you may as well call it unlimited rights.

UNLIMITED

This terms means the image can be used an unlimited (unspecified) number of times within the time period sold. This does not allow a transfer of copyright to the agency or to their client, nor does it mean the same as "unlimited time." You have sold only the rights to use the image, not for your client to resell it or allow a third party to use it.

TOTAL BUYOUT OF RIGHTS, USAGE AND COPYRIGHT

You have sold the copyright to the image, and the client has full rights to do whatever they want with the image. They own it, basically.

Exclusivity

You may sell exclusivity of all images, which will prevent you from reselling any of the images during the time period your client has purchased. Unless otherwise stated, an artist has the right to sell an image to another client at any time—even if it is one currently licensed to a client. Use discretion if you chose to do so, however. Usage defaults to non-exclusive rights to the selected images only if not otherwise stated.

EXCLUSIVE

The image—and the outtakes, if specified—cannot be sold to anyone else during the time period sold.

EXCLUSIVE TO INDUSTRY

The image cannot be sold to anyone else within the same industry (liquor, banking, etc.).

NON-EXCLUSIVE

The image (and the outtakes) can be sold to other clients at any time.

Geographic Region

The following categories specify the geographic area in which an image can be used.

NATIONAL

United States only. Includes provinces of the United States, such as Puerto Rico and islands in the Caribbean.

NORTH AMERICA

Includes the United States and its provinces, and *usually* Canada and Mexico.

GLOBAL OR INTERNATIONAL

Throughout the world (use on the Internet is automatically global).

LOCAL

A specific city or area (for example, the San Francisco area).

REGIONAL

A specific region (the Midwest, Southeast, etc.).

EUROPE

Europe is often negotiated as a neat little package that includes Great Britain, Spain, France, the Netherlands, Scandinavia, Germany, and Italy.

BY COUNTRY

Specific countries can be sold, but if the exposure is large, such as Europe, it may be wiser to go with Global to make sure you are covered.

Market

This category also gives the artist an idea of the degree of exposure. Consumer advertising generally receives more exposure and at a premium cost, while trade advertising is neither as expensive nor as far-reaching in exposure. Editorial is relatively cheap.

CONSUMER

This is usage that markets to "people who buy things"; it is purely for commerce (sells things), and the artist should have a piece of the action because of the high degree of exposure.

TRADE

Markets to "people who sell things to others"; it is lower down on the food chain and therefore not as expensive.

EDITORIAL

This is usage that is informational in nature, and not for commerce. Magazine layouts and textbooks fall into this category.

Usage Categories

These categories further define how the images will be used. They can be segmented further by defining specific media for each.

ADVERTISING

A medium that sells something, like an ad or an outdoor board.

PROMOTIONAL

A medium that promotes something, like a poster for an event such as a concert.

PUBLIC RELATIONS

Similar to Promotional, but more awareness-driven and less commercial.

CORPORATE

Annual reports or internal materials like sales kits.

EDITORIAL

Informational in nature, not commercial. The image may accompany a newspaper or magazine article or be included in a textbook.

Media

Media usage describes where an image will be seen and can be defined as precisely as you choose. As with your photography, negotiating with talent for the specific media will directly affect your costs. Broadcast use is seldom needed but can be sold if necessary.

ANY AND ALL MEDIA

Covers *everything:* all print, OOH (out of home), POS (point of sale), Electronic, and Broadcast. "Any" and "All" are somewhat redundant, but the title of this category drives home the idea that everything is covered.

ALL PRINT

Generally, anything printed onto paper that you can hold in your hand: a newspaper, a magazine, collateral (a mailer, brochure, etc. that features work you've done), and direct mail. You may expand your negotiations to include POS (point of sale) or OOH (out of home) by adding it specifically; otherwise, they are generally not included under this category. Exceptions may include GO cards (free postcard-size take-aways offered in displays in restaurants or entrances to public spaces) or similar limited-exposure items.

NEWSPAPER

Use this category in conjunction with Geographic Region. The size at which the images will run (full-page, half-page, quarter-page) is also a factor in negotiating a fee.

MAGAZINE

Use this category in conjunction with Market segments and with specific publications.

COLLATERAL

Includes anything in print that "goes along with" the campaign but is of secondary importance. Things like brochures, some mailers, and bill stuffers fit under this category.

DIRECT MAIL

Pieces that are mailed to people. The number of pieces used and the Geographic Region both affect pricing. Where the image is seen also makes a difference—whether it's on the cover, envelope, etc.

ISM (IN-STORE MARKETING), POINT OF SALE (POS), OR POP (POINT OF PURCHASE)

Things that will be seen where the product is sold. Banners, signage, counter cards, displays, in-store posters, table tents, hangtags (hangtags could also be considered Packaging, so clarify this during negotiations).

PACKAGING

Something that contains or is attached to merchandise during its sale.

OUT OF HOME (OOH) OR OUTDOOR

Virtually anything seen outside of your home: outdoor boards, bus sides, transit stops, rail cards, GO cards (free postcard take-aways).

TRADE SHOW

Trade-show booths or materials used in a trade show. Show attendance and how the image will be used must be discussed.

ELECTRONIC

Media that is not printed: Internet, CDs for distribution, kiosks, in-store digital media, Jumbotrons, screensavers, and a host of others. Unless you negotiate rights for this specifically, images cannot be resold for this purpose. Because some of these uses can be considered ISM (In-Store Marketing) or OOH (Out of Home), this is a nebulous area.

INTERNET

Global Internet use. Where it will be seen (home page or inside page) may affect pricing. Sometimes the number of hits also makes a difference.

BROADCAST

Television.

MISCELLANEOUS

Things like ad planners (templated materials that can be customized by, say, a franchise to create their own advertising materials) must be negotiated apart from the other media because of the potential for widespread, undetermined use. Items for resale (limited-edition posters, T-shirts, etc.) must be negotiated separately.

Body of Works

This includes all of the images shot for the project, not just the selected image or images. You may often automatically sell rights to the entire body of works, but be sure to specify if you decide to sell the rights to only the selections. You will need to clarify at the beginning of the negotiation so there is no confusion later. You will also want to include a clause regarding whether or not outtakes may be sold as stock until the rights on the selections expire.

Reuse

Because the exact date of first use may not be known at the time rights are sold, it follows that the date of expiration may not be exact. Factoring in the average time it takes to put an image through production after it is created, a rule of thumb is that first use generally begins about two months after the shoot date.

With the proper verbiage, you can create a checks-and-balance system to give the client an opportunity to decide if they want to purchase reuse. I recommend stating that the "client reserves first option of reuse upon expiration of current rights." If the client does not renew the option, then at least you have given them the courtesy of first right of refusal and you can eliminate the "I wonder if it's okay" situation. And you may end up with a reuse fee.

Miscellaneous

You will want to include the right to use the images for your own self-promotion during the rights period the client has purchased. Although this is usually not a problem, it doesn't hurt to have it stated explicitly.

Be sensitive about showing images that have not been made public yet. Clients get very upset if an image is seen before their big launch, especially with confidential products.

Examples of Usage Verbiage

Here are some samples of how to phrase your usage statement:

>> *One year unlimited exclusive international advertising and promotional rights and usage in any and all media for entire body of works, effective date of first use.* Artist retains self-promotion rights forever, as does the agency. Client reserves first option of reuse upon expiration of current rights.

>> *Two years unlimited exclusive regional (Minnesota, Wisconsin, and Illinois) advertising and promotional rights and usage in direct mail for entire body of works, effective date of shoot.* Artist retains self-promotion rights forever, as does the agency. Client reserves first option of reuse upon expiration of current rights. Image may be digitally enhanced in post-production.

>> *Unlimited exclusive global advertising and promotional rights and usage in any and all print for an unlimited time.* Includes entire body of works. All images, including outtakes, will not be sold as stock until all usage expires. Client reserves first option of reuse in additional media. Artist retains self-promotion rights forever, as does the agency.

>> *Total buyout of rights, usage and copyright.* Artist retains self-promotion rights. (Note: The word "buyout" by itself is meaningless and has not been established as an acceptable legal term.)

APPENDIX B

CD CONTENT: FORMS TO DOWNLOAD

The CD included with this book contains 21 forms and templates in Microsoft Word and Microsoft Excel that photographers can download to help them with various aspects of their business.

You can use the forms in two ways. Print out the PDFs and write on them by hand, or make entries to the Word and Excel documents by typing into the documents as they appear on your computer screen, then print them out. The one exception is the Contract Database Template, which is to be used just as a digital file.

The documents provided are examples. Certain wordings or items noted may not pertain to a particular job and/or may not agree with your business practices. You can adapt the Excel and Word files to suit your purposes more precisely.

The pages that follow present an image of each form and instructions for its use.

Table of Contents for Appendix B

Annual Budget

This "reality check" document helps you plan how much you will spend over the course of a year and what you will spend it on. Review the items listed on the sheet, changing the amounts according to your available funds. Add items as you see fit, and remove any that do not apply to your business. Insert prices for all and calculate the total amount. If the total is not realistic, review the individual items, tweaking them until you have a workable budget. (See also pages 26–27.)

ANNUAL BUDGET	Estimate
Website revamp	$2,000.00
Online resources	$0.00
Organization memberships - ASMP	$350.00
Web hosting	$100.00
Brand design	$3,000.00
Portfolio	$600.00
Support portfolio (mini-portfolio)	$200.00
Agency Access membership	$925.00
Agency Access 12k bundle	$600.00
Printed mailer (estimate $1 per name min.)	$0.00
Follow-up mailer (2% of database x mailings)	$500.00
Campaign manager	$550.00
Wise Elephant (calling service)	$500.00
Holiday gifts	$1,000.00
Consulting	$850.00
Stock consultant	$400.00
Travel	$1,000.00
Dream clients	$500.00
Contests	$200.00
TOTAL	**$13,275.00**

These numbers are shown as examples only.
Please research prior to setting your budget.

ANNUAL CALENDAR

	A LIST DREAM CLIENTS	B LIST MASS MARKETING	C LIST HUMAN CONTACT	D LIST EXISTING CLIENTS	E LIST MISC
JANUARY	Conceptualize 4-part campaign	1/1 e-promo -- #k contacts + follow up with click-through report	Meet with 1 new person & 1 existing contact or client	Prepare exisitng client list & industry contacts	Create follow-up card & update website
FEBRUARY	Create materials	Printed promo to #k of contacts	Meet with 1 new person & 1 existing contact or client		Shoot
MARCH	Send first part of campaign	3/1 e-promo -- #k contacts + follow up with click-through report	Meet with 1 new person & 1 existing contact or client		
APRIL			Meet with 1 new person & 1 existing contact or client		Shoot
MAY		5/1 e-promo -- #k contacts + follow up with click-through report	Meet with 1 new person & 1 existing contact or client		
JUNE	Send second part of campaign		Meet with 1 new person & 1 existing contact or client		Update website
JULY		7/1 e-promo -- #k contacts + follow up with click-through report	Meet with 1 new person & 1 existing contact or client		
AUGUST		Printed promo to #k of contacts	Meet with 1 new person & 1 existing contact or client		Stock
SEPTEMBER	Send third part of campaign	9/1 e-promo -- #k contacts + follow up with click-through report	Meet with 1 new person & 1 existing contact or client		Gallery show
OCTOBER			Meet with 1 new person & 1 existing contact or client		
NOVEMBER		11/1 epromo -- #k contacts + follow up with click-through report	Meet with 1 new person & 1 existing contact or client	Update client list -- Plan holiday gifts	REVIEW 2008
DECEMBER	Send fourth part of campaign		Meet with 1 new person & 1 existing contact or client	Holiday gifts: $XXX	PLAN 2009

The dates that appear are estimated dates. Work with your database company to set the actual dates for mailings.

Annual Calendar

This form puts your marketing plan into calendar format. The columns break out the efforts you will make to reach the various groups and organizations that are important to your success. Once you've constructed your annual marketing plan, print out this calendar and post it on a wall near your desk. Keeping your marketing timetable in constant view and—most important—following this "to do" list will take you a long way toward success. (See also pages 118–121.)

Approved Job Check-Off list

Project: _____
Client: _____
Usage: _____

Material for client/shoot	Created	Printed	Notes
Call sheet			
Production book			

Fees	Dates scheduled	Hired, purchased, or rented	Notes
Creative fee for execution and usage			
Shoot fee			
Usage fee			
Pre-light fee			
Post-production			
Tech scouting			
Travel fees			
Weather delay			
Casting			
Casting fee			
Casting location			
Casting materials			
Talent negotiation fee			
Crew			
First assistant			
Second assistant			

Approved Job Check-Off List

This checklist corrals all the information you might need while producing a job, helping you make sure you are "covering all the bases" of the project. Here the first page only is shown; see the PDF provided on the disk for an image of all the elements this form provides. Once you've gone through the list and made notes, review it with your producer or assistant. Add or change items so that the document best supports a particular project.

Budget Overages

If something needs to be added on the set and you haven't included it in your estimate, you will need to have the amount approved. If you get a signature on this ready-to-use form, you will be protected when you submit your final invoice. Print it out and take a few copies with you on all commercial or produced editorial shoots. Revise it as needed. (See also page 152.)

Budget Overages

Pre-pro/After estimate approval/On-set

Job # _____
Client _____
Project _____

Photographer _____
Producer _____

Overage amount $ _____
Overage item(s) _____

Reason _____

Approval signature _____
Printed name _____
Title _____
Date _____

By signing this overage report, the client agrees to pay the overage incurred subsequent to approval of the estimate provided by the photographer and/or agent and/or production company. This overrides any approval from a third-party cost consultant.

Call Sheet

A record of phone numbers will help you keep in touch with everyone involved in the shoot. E-mail it to all personnel, print it out and keep it with you on the set, and have multiple copies on hand. It's especially nice to include this and other relevant forms (casting info, releases, etc.) in a folder for the client; many photographers and producers call such a folder the "production book." (See also page 146.)

CALL SHEET

	Name	Number(s)
Agency		
Account executive		
Art director		
Art buyer/producer		
Photographer		
Representative		
Producer		
First assistant		
Second assistant		
Digital technican		
Location scout		
Wardrobe stylist		
Wardrobe assistant		
Prop stylist		
Prop assistant		
Hair & makeup		
Groomer		
Hair stylist		
Makeup artist		
Studio rental		
Car service		
Car rental		
Messenger service		
Caterer		
Equipment rental		
Model		
Model		
Model		
Model		
Model		
FedEx/UPS number		

Contact Database Template

Type onto the Excel document the names of your existing clients and those you are targeting for work in the future. Having your own personal "database" of your current clients and industry contacts can be invaluable. Use it in several ways—for example, as an aid in your marketing efforts, to keep track of existing clients, and to plan for your holiday gift-giving. Update your database every three to six months. If you are working with a database company or mailing house, ask them to incorporate your own database into mailing lists you purchase from them. The template has all the information a mailing house will need to include your list of names in your mailings.

Contact Database

LAST SPOKE	EMAIL	FIRST NAME	LAST NAME	COMPANY	STREET	CITY	STATE	ZIP	PHONE	NOTES	ANNUAL BILLING

Estimate Check-Off List

This detailed checklist helps you prepare for bidding a job. The various sections remind you what you might need and what to charge for. Here the first page only is shown; see the PDF provided on the disk for an image of all the elements this form provides. Keep a printed-out checklist in an area where you can easily find it.

Estimate Check-Off List

Project: _____
Client: _____
Usage: _____

Fees	Days needed	Per-day rate	Total for estimate
Creative fee for execution and usage			
Shoot fee			
Usage fee			
Pre-light fee			
Post-production			
Tech scouting			
Travel fees			
Weather delay			
Casting			
Casting fee			
Casting location			
Casting materials			
Talent negotiation fee			
Crew			
First assistant			
Second assistant			
Third assistant			
Digital technican			
Wardrobe stylist			
Wardrobe assistant			

ADD LOGO & COMPANY NAME

Estimate/Invoice (remove one)

DATE:

Attn:

JOB TITLE:
ART BUYER:
ART DIRECTOR:
JOB #:
LOCATION:
DATE(S):
Image description

Creative
Creative fee:
Images:
Usage:

Expenses

Digital capture fees	1 @	$0.00	x	1	shots	$0.00
Production crew						
Producer	1 @	$0.00	x	1	days	$0.00
Assistant producer	1 @	$0.00	x	1	days	$0.00
Location scout	1 @	$0.00	x	1	days	$0.00
Lead assistant	1 @	$0.00	x	1	days	$0.00
2nd assistant	1 @	$0.00	x	1	days	$0.00
Grip	1 @	$0.00	x	1	days	$0.00
Prop stylist	1 @	$0.00	x	1	days	$0.00
Assistant prop stylist	1 @	$0.00	x	1	days	$0.00
Wardrobe stylist	1 @	$0.00	x	1	days	$0.00
Assistant wardrobe stylist	1 @	$0.00	x	1	days	$0.00
Food stylist	1 @	$0.00	x	1	days	$0.00
Hair & makeup	1 @	$0.00	x	1	days	$0.00
Talent	1 @	$0.00	x	1	days	$0.00
Locations	1 @	$0.00	x	1	days	$0.00
RV	1 @	$0.00	x	1	days	$0.00
Equipment rental	1 @	$0.00	x	1	days	$0.00
Model maker	1 @	$0.00	x	1	days	$0.00
Props						$0.00
Delivery	1 @	$0.00	x	1	days	$0.00
Wardrobe						$0.00
Catering	1 @	$0.00	x	1	days	$0.00
Craft services	1 @	$0.00	x	1	days	$0.00
Insurance	1 @	$0.00	x	1	days	$0.00
Retouching	1 @	$0.00	x	1	days	$0.00
Mileage	1 @	$0.49	x	1	days	$0.00
Cell	1 @	$0.49	x	1	days	$0.00
Miscellaneous						$0.00
					Total expenses	$0.00
Total fee						**$0.00**

Please make all payments payable to:
Company Name & Address

EXAMPLE TERMS: Upon approval, a 100% advance of final estimated expenses will be due before pre-production can begin. The balance will be due within 30 days of the final invoice date.

Estimate/Invoice

If you do not want to use an estimating and invoicing program like Blinkbid (www.blinkbid.com), this Excel document provides an estimating and invoicing template. Clean and easy to read, it's set up in a professional way and ready for you to enter your numbers. At the top of the form, make it yours by adding your own type treatment or logo and/or company name. If you are using the form for an estimate, remove "Invoice" from the heading. When you create your final invoice, remove "Estimate," and show the same line items as you did on the estimate, with any needed adjustments or added items (see Budget Overages form, page 195). When final billing, you will also need to add the client's purchase order (PO) number. Please note: Documents like this are subject to human error; be sure to review the document two or three times, checking your entries and calculations to be sure everything is correct. (See also pages 137–141.)

Estimate Questionnaire

This set of questions will help you prepare for bidding a job. Have a printout of the form close at hand so you can use it when speaking to a potential client on the phone. It will remind you to ask important questions and will help you start to form an idea of what you will need to charge for. (See also pages 124–137.)

Estimate Questionnaire

Today's date _____
Estimate due _____
Name _____
Art buyer _____ Art director _____ Other _____
Art director's direct line _____ e-mail _____
Address _____ ☐ agency ☐ design ☐ editorial ☐ other
Phone _____ Fax _____
Project _____

☐ B/W ☐ Color ☐ Digital ☐ Deliverable format _____
Can we talk with the art director?
Do you have a bid sheet? _____
Do you have layouts? _____
Budget: $ _____
Usage: ☐ print/magazine ☐ newspaper ☐ out of home ☐ collateral ☐ point of sale
☐ electronic ☐ TV ☐ other _____
Time frame _____
Territory _____
Optional uses needed on estimate _____
Film: ☐ B/W ☐ Color ☐ B/W & color
Prints needed and what size _____ Range _____
Casting: ☐ actual ☐ digital ☐ Polaroids ☐ comp cards ☐ website
Talent specs: sex ___ race _____ age ____ budget range _____
Talent specs: sex ___ race _____ age ____ budget range _____
Talent specs: sex ___ race _____ age ____ budget range _____
Casting due _____ website _____
Location: Scouting ☐ yes ☐ no Where? _____
Location scouting due _____ website _____
Travel: Include costs for the agency? ☐ yes ☐ no
Van rental for equipment? ☐ yes ☐ no
Car rental: Photographer ☐ yes ☐ no Agency ☐ yes ☐ no
Motor home: ☐ yes ☐ no
Hotel booking for agency: ☐ yes ☐ no How many people? _____
Stylists:
Hair: ☐ yes ☐ no Makeup: ☐ yes ☐ no
Wardrobe: ☐ yes ☐ no Style of wardrobe per talent _____
Needed on set? ☐ yes ☐ no
Props: ☐ yes ☐ no Items needed _____
Prop stylist needed on set: ☐ yes ☐ no
Meals: How many agency/clients on set? : _____ Dietary restrictions _____
How many days? _____ How many meals per day? _____
How many agency personnel? _____ How many crew? _____

Final fee on estimate $ _____
Final estimate submitted $ _____ Estimate submitted (date) _____
Job awarded? ☐ yes ☐ no
If no, it was awarded to _____

Location File

It's good to have all the details about a potential location organized and at your fingertips, and then to have a record of those details for the location you select. Take this form with you when you are looking for a location, or give it to your location scout, to capture such details as address, the position of the sun, and whether insurance or a police presence is required.

Location File

DATE: _____
PICK: _____

Location: _____
Name: _____
Address: _____

Owners/rental name: _____
Owners/rental numbers: _____
Office: _____
Cell phone: _____

Time of location scouting: _____ am _____ pm

Rental/usage fee:
Police detail required: _____ yes _____ no
RV/motor home required: _____ yes _____ no
Cleaning fee required : _____ yes _____ no
Insurance required: _____ yes _____ no

NOTES:

Direction of the sun:
North
West East
South

PHOTOGRAPHER WORKSHEET

PHOTOGRAPHER WORKSHEET Date _____

Where was I? _____
Where am I now? _____
Where do I want to go? _____

Budget for the year: $_____
Goal timeline start date: _____
Goal completion date: _____

Do I need assistance: yes / no
If yes, who? _____

Do I have a marketing plan in place? yes / no
Do I have a database? yes / no
If no, who will I purchase one from? _____

Do I have my arsenal of answers/resources prepared?

- ❑ Day rate (editorial and commercial)
- ❑ Forms ready (estimate template, estimate questionnaire, etc.)
- ❑ Crew researched (producers, assistants, stylists, etc.)
- ❑ Industry resources (negotiator, consultant, etc.)

Previous lessons to take forward: _____

What do I need?
- ❑ Portfolio
- ❑ Website
- ❑ Brand design
- ❑ Marketing plan
- ❑ Database
- ❑ Creative outlets
- ❑ Support

Photographer Worksheet

These are the questions you need to ask yourself if you are a photographer looking for assignments. Use it to help you focus. Sit down for a half hour and answer these questions honestly. Other forms that appear on the CD, particularly the annual budget and calendar, will help you "fill in the blanks" on this one. Some of these questions may lead to you others that don't appear here. Think of this form as a springboard to your greater knowledge of yourself as an assignment photographer. (See also pages 8–11.)

Portfolio Requests

It's important to remember where you've sent your portfolio. This tool will help you keep this information organized.

Portfolio Requests

Date	Project/Client	Portfolio Sent	Promo Sent	Returned	Project Awarded	NOTES

Prop Check-In Sheet

Depending on the size of a shoot, you may have dozens of props to keep track of, and this form will help you do that. The project's photographer, producer, stylist, and others may have items to enter on this sheet. If a shoot will continue over several days, use the sheet to do periodic checks that all items are secure. At the end of the shoot, use this form in conjunction with the Prop Disposal Sheet.

Prop Check-In Sheet

Date _____ Job number _____

Client _____ Job name _____

Shoot date(s) _____ Photographer/ location _____

Prop item (with description)	Price (receipt required)	Retailer or rental supplier	Selected and used	Not selected and returned

Prop Disposal Sheet

Date _____ Job number _____

Client _____ Job name _____

Shoot date(s) _____ Photographer/ location _____

Prop item (with description)	Price (receipt required)	Donate, purchase, or return	Donated to (receipts required)	Purchase price (must be at least 50% of the original cost)

Prop Disposal Sheet

When a shoot is over, all props that have been rented must be returned, and this form will help you keep track of that process. In addition, you can use this form to account for items that belong to the client or have been purchased. Like the Prop Check-In Sheet, this form can be used by the photographer, the producer, the stylist, or others on the set.

Property Release

On some shoots, you may use a property (location) for which permission is required. That's when this form comes into play; this release is essential if the property is privately owned. Neglecting to get permission for the use of a particular property can jeopardize the success of an entire shoot. (See also pages 147–148.)

Property Release

Client _____
Job # _____
Job description _____
Photographer_____
Producer _____

Property name _____
Address_____

Phone number_____

Usage: Unlimited advertising and promotional rights for an unlimited period of time.

By signing this release, I give [**agency and client**], their agents, representatives, its agents, representatives, successors, and assigns, the absolute right and permission to take and use photographs of the above named property and to use its name for the usages stated above.

I understand that [**agency**] will be granted full permission to copyright in their name and use, alter, and publish, in whole or in part, such photographs of the property, and that [**agency and client**] shall solely own the copyright to the reproduced images.

I waive any rights to inspect the finished work and/or product or to approve its use.

I hereby release [**agency**], [**client**], [**photographer**], and any person acting with their permission and authority, from any liability due to distortion, alteration, blurring, or positioning that may occur in the process of producing or reproducing the photography.

No further claims will be made by me, my heirs, successors, or assigns.

I hereby warrant that I am of legal age and have every right to contract in my own name the permissions granted above. I have read this authorization release and agreement and am fully aware of its contents and implications.

_____ _____
Print Name Date

Signature

_____ _____
Witness Date

Talent Booking Worksheet

Page _____
Date _____
Client _____ Project _____

Pick #	Talent Name/Agency	Avail.	Out	2nd	Booked	Confirmed	Notes

Talent Booking Worksheet

This form allows you keep a neat record of information on the models you have hired.

Talent Casting Form

Talent Casting Form

Date _____

Pick _____

Client _____

Job name _____

Job number _____

Talent name _____

Talent phone _____

Agent phone _____

Agency/agent _____

Parent (if minor) _____

Best time of day to be reached _____

Hair color _____ Eye color _____

Height _____ Weight _____

Shirt _____ Collar _____ Sleeve _____

Dress _____ Shoe _____

Pants _____ Waist _____ Inseam _____

Hat _____ Bra _____

Are you available on _____ yes / no

Please list any date conflicts. _____

Please list any jobs you have worked on that might
conflict with this client's project. _____

You will want to keep one of these forms for each model you cast for a shoot. Print it out and have the model fill it out, then staple it to the model's photo or make a note on the form of the image in which the model appears.

Talent Release

Once signed, this form gives you and your client permission to use the talent's (model's) face or likeness in advertising images; such a release is not needed for editorial shoots. Neglecting to get the model's permission through the use of this form can jeopardize the success of an entire shoot. (See also page 147.)

Talent Release

Client _____

Job # _____

Job description _____

Photographer _____

Art director _____

Usage _____

Talent _____

Agent/agency _____

Rate _____

By signing this release, I give [**agency and client**], their agents, representatives, successors, and assigns, the absolute right and permission to use photographs or likenesses of me as well as to use my name for the above stated usage. I also relinquish any rights to final inspection or approval of the work or finished product.

I understand that [**agency**] will be granted full permission to copyright in their name and use, alter, and publish, in whole or in part, such images, and that [**agency and client**] shall solely own the copyright to the reproduced images.

I understand that [**agency**] is not responsible for any personal injury or harm due to my own negligence. I hereby release [**agency**], [**client**], and all persons acting with their permission or authority from any liability which I, my heirs, successors, or assigns may claim.

I understand that all information regarding this project is highly confidential and that I may not disclose any information, no matter how trivial, regarding product, concepts, or any other aspect related to the project.

I am of legal adult age and have every right to contract in my own name the consent to the rights and usage stated above. I have read the above authorization, release, and agreement and am fully aware of all that it states or implies. If talent is a minor, I am signing as a parent or legal guardian with full authorization to act on their behalf.

_____ _____

Print name Date

_____ _____

Signature of talent or parent/legal guardian Social Security #

_____ _____

Address: talent's (if independent) or agency's Talent or agent's phone #

Terms and Conditions

Not all photographers attach a sheet like this to the estimates and invoices they submit to clients, but if you feel you need it, this document will protect you and your rights. It is a straightforward layout of standard industry terms and conditions, provided by ASMP. Amend the sections as appropriate for your business or for a given shoot.

<div style="border:1px solid #000;">

Terms & Conditions

[1] Definition: "Image(s)" means all visual representations furnished to Client by Photographer, whether captured, delivered, or stored in photographic, magnetic, optical, electronic, or any other media. Unless otherwise specified on the front of this document, Photographer may deliver, and Client agrees to accept, Images encoded in an industry-standard data format that Photographer may select, at a resolution that Photographer determines will be suitable to the subject matter of each Image and the reproduction technology and uses for which the Image is licensed. It is Client's responsibility to verify that the digital data (including color profile, if provided) are suitable for reproduction of the expected quality and color accuracy, and that all necessary steps are taken to ensure correct reproduction. If the data are not deemed suitable, Photographer's sole obligation will be to replace or repair the data, but in no event will Photographer be liable for poor reproduction quality, delays, or consequential damages. Unless otherwise specifically provided elsewhere in this document, Photographer has no obligation to retain or archive any of the Images after they have been delivered to Client. Client is responsible for sending an authorized representative to the assignment or for having an authorized representative review the images remotely during the assignment. If no review is made during the assignment, Client is obligated to accept Photographer's judgment as to the acceptability of the Images.

[2] Rights: All Images and rights relating to them, including copyright and ownership rights in the media in which the Images are stored, remain the sole and exclusive property of Photographer. Unless otherwise specifically provided elsewhere in this document, any grant of rights is limited to a term of one (1) year from the date hereof and to usage in print (conventional non-electronic and non-digital) media in North America. Unless otherwise specifically provided elsewhere in this document, no image licensed for use on a cover of a publication may be used for promotional or advertising purposes without the express permission of Photographer and the payment of additional fees.

No rights are transferred to Client unless and until Photographer has received payment in full. The parties agree that any usage of any image without the prior permission of Photographer will be invoiced at three times Photographer's customary fee for such usage. Client agrees to provide Photographer with three copies of each published use of each image not later than 60 days after the date of first publication of each use. If any Image is being published only in an electronic medium, Client agrees to Provide Photographer with an electronic tearsheet, such as a PDF facsimile or URL of the published use of each such photograph, within fifteen (15) days after the date of first publication of each use. Unless otherwise specifically provided elsewhere in this document, all usage rights are limited to print media, and no digital usages of any kind are permitted. This prohibition includes any rights or privileges that may be claimed under §201(c) of the Copyright Act of 1976 or any similar provision of any applicable law. Digital files may contain copyright and other information embedded in the header of the image file or elsewhere; removing and/or altering such information is strictly prohibited and constitutes violation of the Copyright Act. All fees and expenses payable under this agreement are required irrespective of whether Client makes actual use of the Images or the licenses to use them. Unless specifically provided elsewhere in this document, no reprographic, reprint, republication or other secondary reproduction usages may be made, and usage rights are granted only for one-time, English language North American editorial print editions of the publication listed on the front of this document and six month searchable archive use on the website of that publication.

[3] Return and Removal of Images: Client assumes insurer's liability (a) to indemnify Photographer for loss, damage, or misuse of any images, and (b) to return all Images prepaid and fully insured, safe and undamaged, by bonded messenger, air freight, or registered mail. Unless the right to archive Images has been specifically granted by Photographer on the front of this document, Client agrees to remove and return or destroy all digital copies of all Images. All images shall be returned, and all digital files created by or on behalf of Client containing any Images shall be delivered to Photographer, deleted or destroyed, within thirty (30) days after the later of: (1) the final licensed use as provided in this document, and (2) if not used, within thirty (30) days after the date of the expiration of the license. Failure to return Images on time will result in loss to Photographer due to his resulting inability to license such Images. Client therefore agrees to pay a holding fee of five dollars and fifty cents ($5.50) per day from the return date until the day on which the images are actually received by Photographer. Client assumes full liability for its principals, employees, agents, affiliates, successors, and assigns (including without limitation independent contractors, messengers, and freelance researchers) for any loss, damage, delay in returning or deleting, failure to return, or misuse of the Images.

[4] Loss or Damage: Reimbursement by Client for loss or damage of each original photographic transparency or film negative ("Original(s)") shall be in the amount of One Thousand Five Hundred Dollars ($1,500), or such other amount if a different amount is set forth next to the lost or damaged item on the reverse side or attached schedule. Reimbursement for loss or damage of each non-digital duplicate image shall be in the amount of Two Hundred Dollars ($200). Reimbursement for loss or damage of each digital file shall be in the amount of Two Hundred Dollars ($200). Reimbursement for loss or damage of each item other than as specified above shall be in the amount set forth next to the item on the reverse side or attached schedule. Photographer and Client agree that said amount represents the fair and reasonable value of each item, and that Photographer would not sell all rights to such item for less than said amount. Client understands that each Original is unique and does not have an exact duplicate, and may be impossible to replace or re-create. Client also understands that its acceptance of the stipulated value of the Images is a material consideration in Photographer's acceptance of the terms and prices in this agreement.

[5] Photo Credit: All published usages of Images will be accompanied by written credit to Photographer or copyright notice as specified on the reverse side. If no placement of a credit or copyright notice is specified on the reverse side, no credit or notice is required. If a credit is required but not actually provided, Client agrees that the amount of the invoiced fee will be subject to a three-times multiple as reasonable compensation to Photographer for the lost value of the credit line.

[6] Alterations: Client will not make or permit any alterations, including but not limited to additions, subtractions, or adaptations in respect of the Images, alone or with any other material, including making digital scans unless specifically permitted on the reverse side. Client may not make or permit any alterations, including but not limited to additions, subtractions, or adaptations in respect of the Images, alone or with any other material, including making digital scans unless specifically permitted on the reverse side, except that cropping and alterations of contrast, brightness, and color balance, consistent with reproduction needs may be made. Client may make or permit any alterations, including but not limited to additions, subtractions, or adaptations in respect of the Images alone or with any other material, including making digital scans, subject to the provisions as stated in [7] below.

[7] Indemnification: Client will indemnify and defend Photographer against all claims, liability, damages, costs, and expenses, including reasonable legal fees and expenses, arising out of the creation or any use of any Images or arising out of use of or relating to any materials furnished by Client. Unless delivered to Client by Photographer, no model or property release exists, and it is Client's responsibility to obtain the necessary permissions for usages that require any model or property releases not delivered by Photographer. It is Client's sole responsibility to determine whether any model or property releases delivered by Photographer are suitable for Client's purposes. Photographer's liability for all claims shall not exceed in any event the total amount paid under this invoice.

[8] Assumption of Risk: Client assumes full risk of loss or damage to or arising from materials furnished by Client and warrants that said materials are adequately insured against such loss, damage, or liability.

[9] Transfer and Assignment: Client may not assign or transfer this agreement or any rights granted under it. This agreement binds Client and inures to the benefit of Photographer, as well as their respective principals, employees, agents, and affiliates, heirs, legal representatives, successors, and assigns. Client and its principals, employees, agents, and affiliates are jointly and severally liable for the performance of all payments and other obligations hereunder. No amendment or waiver of any terms is binding unless set forth in writing and signed by the parties. However, the invoice may reflect, and Client is bound by, Client's oral authorizations for additional Images, fees and expenses that could not be confirmed in writing because of insufficient time or other practical considerations. This agreement incorporates by reference the Copyright Act of 1976, as amended. It also incorporates by reference those provisions of Article 2 of the Uniform Commercial Code that do not conflict with any specific provisions of this agreement; to the extent that any provision of this agreement may be in direct, indirect, or partial conflict with any provision of the Uniform Commercial Code, the terms of this agreement shall prevail. To the maximum extent permitted by law, the parties intend that this agreement shall not be governed by or subject to the UCITA of any state. Photographer is an independent contractor and not an employee. If photographer is deemed under any law to be an employee of Client, and if the Images are therefore considered works made for hire under the U.S. Copyright Act, Client hereby transfers the copyright to all such Images to Photographer. Client agrees to execute any documents reasonably requested by Photographer to accomplish, expedite or implement such transfer.

[10] Disputes: Except as provided in [11] below, any dispute regarding this agreement shall, at Photographer's sole discretion, either: (1) be arbitrated in Photographer's City, Photographer's State, under rules of the American Arbitration Association and the laws of Photographer's State; provided, however, that irrespective of any specific provision in the rules of the American Arbitration Association, the parties are not required to use the services of arbitrators participating in the American Arbitration Association or to pay the arbitrators in accordance with the fee schedules specified in those rules. Judgment on the arbitration award may be entered in any court having jurisdiction. Any dispute involving $5,000 or less may be submitted without arbitration to any court having jurisdiction thereof. OR (2) be adjudicated in Photographer's City, Photographer's Stateunder the laws of the United States and/or of Photographer's State.(3) In the event of a dispute, Client shall pay all court costs, Photographer's reasonable legal fees, and expenses, and legal interest on any award or judgment in favor of Photographer.

[11] Federal Jurisdiction: Client hereby expressly consents to the jurisdiction of the Federal courts with respect to claims arising by Photographer under the Copyright Act of 1976, as amended, including subsidiary and related claims.

[12] Overtime: In the event a shoot extends beyond eight (8) consecutive hours, Photographer may charge for such excess time of assistants and freelance staff at the rate of 11/2 times their hourly rates.

[13] Reshoots: Client will be charged 100 percent fee and expenses for any reshoot required by Client. For any reshoot required because of any reason outside the control of Client, specifically including but not limited to acts of God, nature, war, terrorism, civil disturbance or the fault of a third party, Photographer will charge no additional fee, and Client will pay all expenses. If Photographer charges for special contingency insurance and is paid in full for the shoot, Client will not be charged for any expenses covered by insurance. A list of exclusions from such insurance will be provided on request.

[14] Assignment Cancellations and Postponements: Cancellations: Client is responsible for payment of all expenses incurred up to the time of cancellation of the assignment, plus 50 percent of Photographer's fee; however, if notice of cancellation is given less than two (2) business days before the shoot date, Client will be charged 100 percent fee. Postponements: Unless otherwise agreed in writing, Client will be charged a 100 percent fee if postponement of the assignment occurs after photographer has departed for location, and 50 percent fee if postponement occurs before departure to location. Fees for cancellations and postponements will apply irrespective of the reasons for them, specifically including but not limited to weather conditions, acts of God, nature, war, terrorism, civil disturbance, and the fault of a third party.

*SPECIAL NOTE: PHOTOGRAPHER WILL RECEIVE APPROVAL FOR OVERTIME & ADDITIONAL EXPENSES FROM AGENCY REPRESENTATIVE/CLIENT PRIOR TO EVENT.

Copyright by ASMP.org

PLEASE REVIEW THIS DOCUMENT BEFORE USING AND MAKE CHANGES BASED ON YOUR OWN GUIDELINES. THIS IS SOLEY A TEMPLATE TO GET YOU STARTED.

</div>

Wardrobe Check-In Sheet

You must keep track of all wardrobe items purchased or rented for a shoot. As with the Prop Check-In and Prop Disposal sheets, this form is to be used by the photographer, producer, stylist, or others. If a shoot will continue over several days, use the sheet to do periodic checks that all items are secure. At the end of the shoot, use it in conjunction with the Wardrobe Disposal Sheet.

Wardrobe Check-In Sheet

Date _____ Job number _____
Client _____ Job name _____
Shoot date(s) _____ Photographer/ location _____

Wardrobe item (with description)	Price (receipt required)	Retailer or rental supplier	Selected and used	Not selected and returned

Wardrobe Disposal Sheet

Date _____ Job number _____
Client _____ Job name _____
Shoot date(s) _____ Photographer/ location _____

Wardrobe item (with description)	Price (receipt required)	Donate, purchase, or return	Donated to (receipts required)	Purchase price (must be at least 50% of the original cost)

Wardrobe Disposal Sheet

When a shoot is over, all wardrobe items that have been purchased, borrowed, or rented must be returned or otherwise disposed of, and this form will help you keep track of that process. And you can use pages from this form to account for items that belong to the client or have been purchased. Like the Wardrobe Check-In Sheet, this form can be used by the photographer, the producer, the stylist, or others on the set.

INDEX